DRUID HILL PARK

THE HEART OF
HISTORIC BALTIMORE

EDEN UNGER BOWDITCH
AND ANNE DRADDY

Charleston History London
PRESS

Published by The History Press
Charleston, SC 29403
www.historypress.net

First published 2008

Manufactured in the United Kingdom

ISBN 978.1.59629.209.3

Library of Congress Cataloging-in-Publication Data
Bowditch, Eden Unger.
 Druid Hill Park : the heart of historic Baltimore / Eden Unger Bowditch.
 p. cm.
 Includes bibliographical references and index.
 ISBN-13: 978-1-59629-209-3 (alk. paper)
 1. Druid Hill Park (Baltimore, Md.)--History. 2. Baltimore
(Md.)--History. 3. Baltimore (Md.)--Buildings, structures, etc. 4.
Landscape architecture--Maryland--Baltimore. 5. Baltimore (Md.)--Biography.
I. Title.
 F189.B17D783 2007
 975.2'6--dc22
 2007017131

This publication has been financed in part with state funds from the Maryland Historical Trust, an instrumentality of the State of Maryland as part of the Department of Planning. However, the contents and opinions do not necessarily reflect the views or policies of the Maryland Historical Trust or the Department of Planning.

To my three loving, patient, caring and brilliant children—Julius, Lyric and Cyrus. Remember, no matter where you go in life, you will always come from Baltimore. This is the story of your home.
To Nate, the one and only love of my life. Thank you for making this ours.
And for Anne Draddy—this is your legacy too.
—Eden Unger Bowditch

I dedicate this book to the users and lovers of Druid Hill Park. This park, along with the more than four hundred other parks in Baltimore, provides a vital resource to our residents and acts as a strong, healthy anchor to our neighborhoods. The sheer size of Druid Hill Park makes it a citywide amenity, a place for people to relax and connect with others and nature.
—Anne Draddy

"Persons alive to the charms of a landscape will find at every move or turn new scenes bursting upon the vision." —Howard Daniels on Druid Hill Park, from his article "The Public Park for Baltimore," circa 1860

Contents

Preface

Whoever said "the future, infinite, the past, finite" never attempted to do research into the vast stores of history. When faced with history's daunting labyrinthine paths, the ever-reaching branches that not only descend a trunk but also dig deep into the earth as roots, one realizes that the past is as infinite as the future. Family trees do not end. Instead, family trees, at the farthest branches or deepest roots, become obscured by the years. They become unreachable in the present because we simply cannot see through the depths that hold them. This was simply going to be a book about a park. But researching into Druid Hill Park's past, I found that every branch led not only to more branches, but also to more trees. This web stretched not only into our own colonial history, touching the branches that held George and Martha Washington and Patrick Henry, but out across the miles into Europe, with the Marquis de Lafayette, and far back across the years to even Robert the Bruce of Scotland. This book could have been a project that spanned years just to get the lineage in some kind of working order. Druid Hill Park seems to have touched so many lives; so many people have come into contact with it, even if only by the suggested six degrees of separation. Having a home basically in the park, it has been an honor for me to get a chance to tuck into this delicious story and learn something about my own acquired heritage since I, too, am now a part of it.

Eden Unger Bowditch

Over the last few years, I have fallen in love with Druid Hill Park. It is a case of "to know it is to love it." The funny thing is that not many Baltimoreans are well acquainted with Druid Hill. Many visit for a single purpose, such as a family reunion or to play soccer or tennis. Some folks take a trip to the zoo or the conservatory and head straight home. They are not aware of the mystery and beauty of Druid Hill. By spending a little time in the park, walkers and cyclists may stumble upon hidden historic structures and experience the beautiful forests filled with immense oak, beech and tulip poplars, as well

as find the vistas at Prospect and Tempest Hills. On summer days, a visitor can sit in air conditioning under the oak groves or spy a healthy red fox trotting quietly across the back roads. Recently, more people have been discovering the charms of the park with its fantastic view of downtown along the 1.5-mile exercise path around the reservoir. A new treat is the 2.75-mile trail winding from south to north, touching many park features. Druid Hill Park offers a retreat from the harsh urban surfaces and noise of the city. It plays a vital role in the health and well-being of our citizens, it is free and open to all and it is located right in the heart of our city.

Anne Draddy
Park Administrator,
Baltimore City Department of Recreation and Parks

Author's Note

Most writers will travel to the place of which they write to garner deeper insight into their topic. If this book had been written on Seneca Street in my home near Prospect Hill in Druid Hill Park, where I could take walks through the park whenever a question came to mind and find answers at my fingertips, then research would have been much more easily accomplished: Just step outside. Just go to the Maryland Room at Enoch Pratt Free Library's Central Branch. Just walk over to the Recreation and Parks Office to chat with the foresters. However, early on in this project my family and I moved across seas and continents to Cairo, Egypt, where the past truly is infinite. I was no longer in my backyard in Druid Hill. Without the talents, friendships, knowledge and commitments of Jeff Korman and Anne Draddy, and others, this book would have had to wait several years to be completed. Jeff Korman is the hero of anyone interested in Baltimore's past. He has certainly been a champion among these pages. Thank you, Jeff. And without Anne Draddy's fierce commitment to Druid Hill Park and enthusiasm for the book project, this could never have happened. Thank you, Anne. And thank you to all of the people who were so incredibly helpful to an author who found herself on the other side of the world from her topic.

Eden Unger Bowditch

Acknowledgements

I would like to thank Anne Draddy and Jeff Korman for their tireless help and support. For assistance in fact-finding, thanks to the ever-knowledgeable Myra Brosius and Tim Almaguer, as well as Ed Shull, Gil Sandler, Mary Porter, Kate Blom, Edward Orser, Grant E.G. Healey and Tom Chalkley. Many thanks (of course) to Jeff Korman, Lee Lears, Peter Devereaux, David Donovan and the other knowledgeable staff members of Enoch Pratt Free Library's Maryland Room. Thanks to Charles Hall for the information on the petroglyphs. Also, I appreciate the assistance from Beate and Antje Schmitz, Shireen Akram-Boshar, Karim Hassan, Jane Cowper, Asmaa Ali, Nahed Davis, Emad Kassan, Leslie Murphy and Don Cardoza. Also, thanks to Jenny Kaemmerlen, Hilary McCullough and Lee Handford from The History Press, and Christopher Becker from the Maryland Historical Society. Thanks to the Maryland Historical Trust, the Department of Recreation and Parks, the Maryland Zoo in Baltimore, the Baltimore Conservatory Association, the Friends of Druid Hill Park…and so many others.

Of course, I would like to thank Lyric Unger Bowditch for her excellent help in editing and Nate Unger Bowditch for all of his help and for being the most wonderful man on the planet, among other things.

Eden Unger Bowditch

Introduction

Parks are indicators of the health and wealth of cities. Baltimore has one of the oldest park systems in the country and each park has its own fascinating history. Druid Hill is no exception. It is the gem of Baltimore's park system, with 135 acres of woods, open treed lawns, a conservatory, a zoo, historic structures, statues, fountains and multiple active recreation venues. Some visitors come to Druid Hill for a game of tennis while others come to take advantage of the bucolic urban splendor, to sit beneath the giant oaks overlooking the reservoir or stroll along one of the winding paths through the ancient forest. The conservatory's tropical scents in the "flower house" on a winter's day can take you to the warm embrace of a tropical island. Our parks provide a respite from our hectic daily lives. They are not luxuries, but necessities in making Baltimore a great city.

When you look into the history of one park, you will often find a trail leading to another. Old estates were connected by families and several of these estates became public parks in the nineteenth century. Family ties historically brought different corners of the city together. John Eager Howard's estate, Belvedere, was open to the public as early as 1790, and Patterson, still privately owned, was given to the city in 1827 as a two-acre square for public use. City law provided for public squares to be created for citizens. Baltimore has a long history of interest in public greenery. Still, the oldest and one of the most intriguing of all these great green spaces is Druid Hill Park.

Today, surrounded by urban neighborhoods, it stands almost directly in the center of Baltimore city limits. This great green expanse on the west bank of the Jones Falls has its own history as a part of Baltimore's history. Reaching back into the seventeenth century, Druid Hill Park's story reads like a novel while making its place along the timeline of Baltimore's past, present and future. Druid Hill Park broke the ribbon, inaugurating the public park system in Baltimore and becoming one of the first large public parks in America. It led the way for other estates and green spaces to become available to average citizens. Today, Baltimore's love of parks is once again on the rise, as monuments of the

city's majestic past are being renewed. The movement in the city to "re-green" itself has given Druid Hill Park a chance to be appreciated by generations to come, in all its beauty and resplendent glory. A tour through this amazing park offers a bucolic adventure in the middle of the city and a view of the past, the present and the future.

Part One

THE PAST

Chapter 1.

The Parcel

It is hard to imagine that Druid Hill Park was, in centuries past, a country estate. The land that makes up Druid Hill Park is part of a long history, going back centuries. The 1600s saw Baltimore (or Baltimore Town) as a busy seaport and an active society. The Inner Harbor, one of the country's oldest seaports, welcomed ships into its waterways. Churches were established and the government ran on English law. There was no currency, tobacco was used in trade and the Lords of Baltimore parceled land.

George Calvert, the first Lord Baltimore, had a willingness to explore new lands in the name of the Crown. Calvert was secretary of state and minister of Parliament under James I until he converted to Catholicism in 1625. Although Catholics were not allowed to serve in high government offices, King James made Calvert first baron of Baltimore, a coastal town in southern Ireland. Calvert's desire for new lands took him to America. From King Charles I, he requested a grant for land just north of Virginia along the Chesapeake, hoping to create a successful colony there. It was not until after Calvert's death that King Charles in 1632 granted George's son, Cecil, ownership of the Chesapeake land (called Terra Mariae) and created the Charter of Maryland. Article XVIII of the charter gave the Lords Baltimore control over all parceling, distributing, granting and patenting of land. This was the case until the American Revolution, and under Charles Calvert, third baron of Baltimore, such was the beginning of the history of Druid Hill Park.

Lord Baltimore acquired much of the regional land, obtaining some acreage from the Susquehannock Indians in 1652. (Susquehannock is an Algonquin word loosely translated to mean "people of the falls" or "people of the muddy river.") It is believed that Druid Hill would have been a desirable place for American Indians due to its proximity to the Jones Falls Stream as well as the multiple springs at the site. Lord Baltimore subsequently began to parcel out the land. During his tenure, the third Lord Baltimore actively recruited eligible men with significant finances who were interested

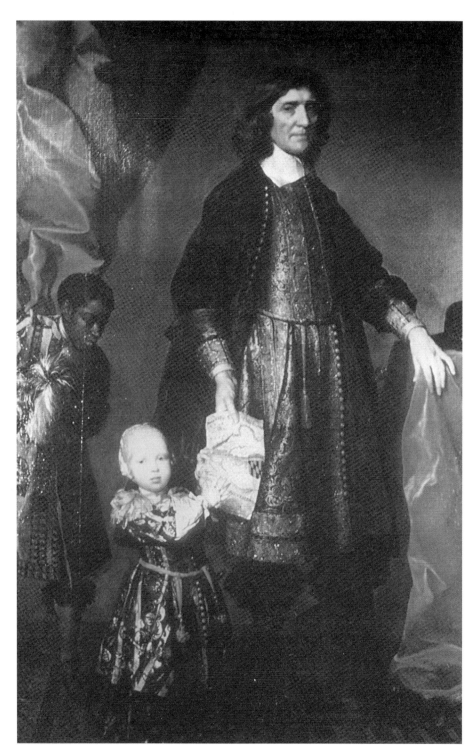

This seventeenth-century painting by Gerard Soest depicts Cecil Calvert, who would have been in power at the time of the painting, and his grandson, most likely Benedict Leonard Calvert, Fourth Lord Baltimore. In Cecil's hand is the charter of the Maryland colony.

in obtaining land patents. On June 30, 1688, Charles, Lord Baltimore, granted a tract of land measuring two thousand acres to Thomas Richardson. It is unclear, as records are incomplete, how such a large parcel of land (equal to enough land to be patented to forty potential gentlemen) was granted to Richardson. He seems to have been a dealer in property, as he began to parcel off the land within a month of his patent being granted. This property contained the land on which Druid Hill Park now stands.

The land stretching west along the bank of the vibrant Jones Falls must have been keenly attractive. Of the 2,000 acres assigned to Richardson, he assigned 350 (although some sources say 300) acres to Thomas Durbing (sometimes spelled Durbin or Darbing). Durbing called it "Hab Nab a Venture." "Hab Nab at a Venture" is a colloquial old English term defined loosely as "hit or miss," "gain or no gain, venturesome." This heavily wooded land was rented for the cost of fourteen shillings per year and made up a large chunk of the northwest section of Druid Hill Park. It more or less extended from the boat lake to the rail tracks (along the Jones Falls) and from the mansion house lawn to Woodberry Avenue, including a section now called Historic Brick Hill, on which stand millhouses from the mid-nineteenth century and caretakers' homes from earlier that century.

In 1703, other parcels of property had joined Hab Nab, with names such as Jones Levil, or the Level—which consisted of two hundred acres from the Columbus Statue to the east side of the boat lake, to the zoo to Liberty Heights Avenue—Hap Hazzard, Happy Be Lucky, Come by Chance and Parrish's Fear (Parrish was another patent owner who had obtained parcels in 1678 as well as in 1714). Although Thomas Durbing's land was perhaps less suitable than the Level for growing tobacco, it was well suited for wood. The land that would become Druid Hill was verdant and well stocked with trees that offered splendid wood. There is speculation that Hab Nab might have been a less than honest title for land so clearly capable of providing for its holder. In a time when carpenters were responsible not only for building but for finding lumber as well, this expanse of land must have been a welcome acquisition. In fact, during this time and after the passing of Thomas Durbing, his son, Christopher, sold parcels of the property to carpenters. Through the first fifteen years of the eighteenth century, the land seems to have been used primarily for lumber and planting. Christopher Durbing sold some of the land to John Eagleston, a carpenter, in 1703 and other acreage to a carpenter named John Gardner in 1705. Gardner went on to acquire several more plots and his property, along with the land later bought by Rogers, makes up the bulk of what is today Druid Hill Park.

THE ROGERS/BUCHANAN LEGACY

This next chapter of Druid Hill Park is the story of two families from different parts of the world, brought together to create one family. In doing so, they created a legacy that would endure for almost a century and a half.

The First of the Rogerses

In June 1716, Nicholas Rogers purchased 150 acres of land from John Eagleston for the price of fifty pounds. It was noted that Rogers was an "Inn-Holder and Planter" and the son of "old Nicholas Rogers of Upton Court." Upton Court was a portion of land in south Baltimore that stretched 500 acres. Nicholas Rogers grew up on and inherited this land after his father's death in 1693. It is also noted that the elder Rogers often wrote his name with the spelling "Rogier," which is how the name is spelled in the *Domesday Book* created by William the Conqueror in 1086. The alternate spelling was not unusual. Nicholas's surname seems to have been brought over to Britain with the Norman invasion of 1066 and to have had its roots in Cornwall. Some families immigrated to America in the early 1600s and it is thought that the Baltimore Rogers family was part of this group.

The younger Nicholas Rogers owned these five hundred acres along with other plots around Baltimore, including part of what is now Patterson Park. He also purchased two hundred acres that were called the Rogers Plantation, which would become part of Druid Hill Park. However, Nicholas Rogers would not have much time to embrace these acres of bucolic splendor. Four years after purchasing the land, when Eleanor Rogers, Nicholas's daughter, was sixteen, Nicholas died. He left Eleanor the two hundred acres of land that would be the seed of Druid Hill. Nicholas also left a widow who was pregnant at the time. She was carrying a son whom she named after her husband, Nicholas. Nicholas Rogers III was born in May 1721 never having met his father.

Two months after Nicholas was born, Mrs. Rogers found a new father for her children. With a babe at the breast, Eleanor's widowed mother (also Eleanor) married a young man identified in records as "Lloyd Harris, Gentleman," suggesting that he came to the marriage with finances. Young Eleanor's baby brother, Nicholas III, grew up knowing only Lloyd Harris as a father. Lloyd Harris, at least in financial terms, treated Nicholas as his own son and provided for him. All accounts show that Harris became the patriarch of the family. From the naming of future children and the closeness he seems to have fostered with his adopted progeny, it appears that he was both a good husband and a real father to Eleanor Sr.'s children.

Lloyd Harris was successful in land endeavors, investments and business. Nicholas, learning from his stepfather, became a well-to-do merchant himself. The young Rogers made successful land acquisitions, became town surveyor and made plans for a wharf. Among other things, Nicholas Rogers III owned a ship, the *Phillip and Charles*, said to be the first square-rigged vessel in Baltimore Harbor. Nicholas married Henrietta Jones in Old St. Paul's Church when he was twenty-four and had four sons and a daughter. Of his sons, three boys survived childhood. He provided in his will for his son Nicholas IV, leaving him land that had been left to his mother by her husband, Lloyd Harris. Nicholas IV was only five when his father died in 1758. As with his own birth, Nicholas III's last child, Eleanor, was born after his death.

Enter the Buchanans (the Scottish Doctor)

The other side of the family behind the Druid Hill story, the Buchanans, can be traced back to the fourth century. The Buchanans crossed over from Ireland to Scotland sometime before 1040. George Buchanan is believed to be of the thirty-fifth documented generation! The line began to use the name Buchanan (from Isle of Buchanan, the name meaning "son of the canon," in Stirlingshire, Scotland) in the mid-thirteenth century. George Buchanan's ancestors fought alongside Robert the Bruce of Scotland. The family had connections to the court of James I and had generations of its own lairds, as well as marriages to aristocracy.

George Buchanan was born in Edinburgh, Midlothian, Scotland, on July 7, 1696, although some records say 1698. His father, Mungo Buchanan, born around 1662, also in Midlothian, was a third son and consequently did not inherit his own father's vast holdings. Mungo made the decision to leave the Scottish Highlands and set out to make his own way. He moved to Edinburgh, where he married Anna Barclay around 1686. In 1695, Mungo Buchanan was an admitted Writer of the Signet (the ancient Scottish legal society dating back, in its origins, to the fourteenth century. It still exists as WS Society or the Society of Writers to Her Majesty's Signet). In 1709, with significant finances, Mungo purchased an estate given the name of Auchentorlie. ("Auchen" is the Gaelic word for "fields"; therefore the estate means "fields of sorlie".)

George was the seventh son of Mungo and Anna. After Mungo's death, Auchentorlie was passed on to George's brother, Andrew, who was one year George's senior. Like his father, George had no prospects of inheriting, so he too set out to make his own way.

He attended Glasgow University in 1717 and studied medicine. In 1723, when Dr. George Buchanan left the land of his ancestors at the age of twenty-five and arrived at Cole's Harbor, Maryland, he had dreams of finding his own way in the world.

The First Rogers/Buchanan Union

George Buchanan did well for himself, acquiring land in the colony of Maryland as his father had done in Dumbartonshire, Scotland. During his first years in Baltimore, Buchanan met and wooed the young Eleanor Rogers, stepdaughter of Lloyd Harris and daughter of the senior Eleanor Rogers. Thus George Buchanan acquired his wife's two hundred acres in the union, marking the beginning of the Rogers/Buchanan legacy.

The year 1729 was an important one in Baltimore history. It was the year that the city of Baltimore Town was laid out and defined. The act of 1729 authorized the erection of Baltimore Town. Not only did George Buchanan attend the first town planning meeting on December 1, 1729, but also he was named city land commissioner (one of seven original commissioners named) and served as a Baltimore City magistrate. By that time, George had established himself as a prominent member of Baltimore society and was an active colonial, serving in several official capacities. It is said that the plans for laying out Baltimore Town were made in George Buchanan's house by the town commissioners.

In January of 1741, George Buchanan purchased the last plots of property that had belonged to John Gardner (Gardner had owned them until his death). For £150 sterling he acquired 150 acres of the original Hab Nab and 200 acres in the Level, making his estate a vast 578½ acres. This estate, one could only imagine, had to represent a great deal for George Buchanan, seventh son of Mungo. George had gone out into the world and, like his father, found his own fortune and his own place in his new society. Perhaps feeling or longing for the connection with his father in the old country, George Buchanan named his colonial domain Auchentorlie. By giving his estate the same name as that of his father's back in the old country, Dr. Buchanan seemed to be making it clear that Maryland truly had become his home.

George Buchanan built a house that may have been destroyed by fire, although records are unclear. He rebuilt a massive abode, virtually a castle, on the site where the first stood and where the mansion house now stands. Old drawings show turrets and architecture that is more reminiscent of a fourteenth-century Scottish castle than a colonial Baltimore home. There is evidence that Buchanan built another house on the property that was referred to as the Colonial House. From the photographs of this structure that have survived, one can see that this second dwelling was modest in comparison to his turreted castle. The Buchanan family may have lived in this spacious but simple home until George's extravagant dwelling was completed. Whatever the original function of the building, the Colonial House survived until 1868 when, in a state of irreparable decay, it was razed by the city.

For a number of years the Buchanan family grew and thrived on the colonial estate of Auchentorlie. By 1747, George and Eleanor had ten children (four daughters and six sons), but on April 23, 1750, Dr. George Buchanan died at the age of fifty-three, leaving

his estate to his eldest son, Lloyd. Lloyd was an attorney working for the Baltimore Town Commissioners. George's youngest son, William, was only two. The family chose a quiet hillside on the estate for their patriarch's burial site. This plot, with its quiet residents, remains today as the family cemetery. George Buchanan was the first to be laid to rest there. (It is located on Greenspring Avenue near the disc golf course.)

Two years later, after a terrible thunderstorm, George's wife, Eleanor, and some of her servants were either struck or otherwise harmed when the house was apparently hit by lightning. Somehow the house was undamaged, but the mistress was struck dumb and the servants were killed, according to a newspaper account in the *Maryland Gazette* of July 30, 1752.

> *Monday late in the afternoon* [July 27], *there was a very violent Gust of Lightening and Thunder, in Baltimore County, which struck the House of Mrs. Buchanan, Widow of the late Dr. Buchanan, about 3 Miles from Baltimore-Town; whereby Mrs. Buchanan was struck speechless for some Time, and a young Woman, Miss Elizabeth Gill, who liv'd with Mrs. Buchanan as a Companion, and was sitting at Work in the same Room with her, was instantly struck dead. Two Negroes were likewise struck down in the Kitchen, but the building received no Damage. A decanter standing on a Chest of Drawers was sploit in Pieces and a large China Bowl was flund to the Ground without being broe or crak'd.*

Mrs. Buchanan died in 1758.

Eleanor and George's eldest son, Lloyd Buchanan, married a young woman named Eleanor Darnell (yes, another Eleanor!). After the death of his father, Lloyd took control of Auchentorlie. He prospered as an attorney and in public service as a commissioner and then assemblyman. However, his home life was marked by tragedy. Eleanor Darnell Buchanan died sometime before 1757, at the age of twenty-seven. The couple had no children. Lloyd remarried and the event was recorded in the *Maryland Gazette* in July 1757. Lloyd wed nineteen-year-old Rebecca Lawson and one month after the announcement, a daughter was born. (Whether this immediate birth was a scandal or not, there is nothing specific written and little mentioned. It is possible that the dates are not correct, as is often the case, or that the announcement came significantly after the time of the actual marriage.) The daughter of this marriage was named (yes, it's true) Eleanor. Then tragedy struck the Buchanan household once again. Lloyd Buchanan lost his second wife, who was then only twenty-two, on Christmas Eve 1759. She died in childbirth. Lloyd and Rebecca's second child, a son, died with his mother. Rebecca Lawson Buchanan was buried alongside Dr. Buchanan in the graveyard at Druid Hill.

Lloyd, apparently feeling unable to raise his daughter alone, sent her to be raised by her maternal grandmother, Dorothy Lawson. He then set about preparing the estate and having it resurveyed. The new patent added land "east and west of Pimlico Drive north of Seven Oaks, including the Grove of Remembrance and the High Service reservoir," giving the property a total sum of 625 acres. He prepared a will, leaving all to his beloved daughter, whom he called Elea. Lloyd provided for his daughter's education

and asked that no sermon be preached over his grave upon his burial. Three years after the death of his second wife, Lloyd died, leaving his four-year-old daughter Eleanor an orphan. Eleanor thus became the sole heir to her grandfather's estate.

History Repeats Itself

Now we have Nicholas Rogers IV and Eleanor Buchanan, two small children growing up in Baltimore. It is with them, in more ways than one, that the story of Druid Hill blossoms. It is also where a familiar series of events takes a voyage across the ocean and back. This couple, the youngest of the Eleanor and Nicholas pairs, would play a most prominent role in the saga of Druid Hill. At the ages of four and five, respectively, they both lost their fathers. Their immediate families were both well-to-do and well established in Baltimore. Eleanor and Nicholas were, in fact, related. They were first cousins, once removed. Although their paths were to be parallel, it would be several more years before they would become linked.

There were now four generations of Nicholas Rogerses: Nicholas, planter; Nicholas, inn holder; Nicholas, merchant and ship owner; and Nicholas, scholar, soldier and architect. Nicholas IV had some traveling to do. Perhaps George Buchanan's story was unknown to him and Nicholas's choice was simply a turn of serendipitous fate, or perhaps Nicholas was familiar with his elder sister's husband's history and chose to use it as a map. Either way, it would come to pass that Nicholas followed in his brother-in-law's footsteps.

Instead of going to pursue his higher education in the United States, Nicholas Rogers IV set out to study in Glasgow. It is believed that in Scotland he developed his love of architecture and landscape design. Like George Buchanan before him, Nicholas attended Glasgow University. He graduated in 1774 but did not return immediately to Baltimore. Instead, he traveled to England and then to France.

Rogers was in Paris when the first shots of the American Revolution rang out. He, along with several companions—Silas Deane, a recent Yale graduate, and Marie Joseph Paul Yves Roch Gilbert du Motier ("A rose by any other name…" Gilbert du Motier is better known in America as the Marquis de Lafayette), a young soldier of fortune—made plans to join the fight. Rogers was recommended to Tronson Ducoudray, a general in the French army, and served as his aide-de-camp with a commission as major. While he was sailing to America with Ducoudray and carrying information from Silas Deane to the Committee of Secret Correspondence, a British ship near American shores took their boat. Details are provided in the "family notes" of Miss Anne Spotswood Dandridge (1813–1890), who was a relative of Patrick Henry, Martha Washington and Alexander Spotswood, and whose lineage reaches back to Robert the Bruce. She was married to Thomas E. Buchanan. She wrote:

> *The French vessel on which Major Rogers sailed was overhauled by an English frigate off Charleston. Neither the Captain nor any of the crew would speak English and Major Rogers, tying up his head and going to bed, escaped for a time by feigning to be a sick*

soldier who cold speak only Latin. The English officer, however, was not satisfied with his first search and ordered the Frenchmen to lie to until daylight; but taking advantage of thick fog, the vessel escaped in the night and put into Charleston. Major Rogers saved his dispatches, they being dragged over the side by a line ready to cut at any moment and let fall into the sea.

Miss Dandridge went on to describe the arrival and subsequent actions of Rogers: "He joined the General Ducoudray's staff Philadelphia. Just before the battle of Brandywine and on the way to field, Ducoudray who was the only officer remaining on horseback, lost his life while crossing the Schuylkill River on a ferry boat." Rogers leapt into the Schuylkill after his commander. Although it is reported that Nicholas Rogers was an excellent swimmer, he was unable to pull Ducoudray to safety. After Rogers himself was dragged out of the water, he jumped in once again for another attempt at rescuing Ducoudray but, heartbroken, was unable to save his leader.

After the war, Rogers returned to Baltimore from Philadelphia. Within five years, in 1783, the preliminary articles of peace were signed, officially ending the American Revolutionary War. That same year, Nicholas Rogers married Eleanor Buchanan (the granddaughter of his father's sister). In Eleanor's absence while she was growing up under the care of her grandmother, Auchentorlie had been cared for and maintained by the slaves of Lloyd Buchanan. He had left specific instructions that although the slaves could be "hired out," they were not to be sold,

"with the Negroes there on be kept going" and that some of them be hired out. None were to be sold. "Old Sarah" and her girl called "Dianah," also "Tom" purchased when he was a boy from Mr. Dallam; and the girl named "Peggy" and others not named in the records: Phil and Joe, and Jim and Sambo, sleek youngsters who gathered the chestnuts in old Hab Nab; fished and swam in Jones falls along the line of Happy Be Lucky; hoed the corn, "tater" and tobacco on The Level, and brought in the cows that may have strayed into Hap Hazard and the Parrish's Range.

The Buchanan slaves lived in relative comfort, tending to and running the estate and working the land in anticipation, one must assume, of the return of their mistress. After their marriage, Eleanor and Nicholas moved back to Auchentorlie to live and the property became more an estate than a plantation.

Here is the circle of events that mark the repetition of history in the Rogers/Buchanan family and Druid Hill Park. Dr. George Buchanan studied at Glasgow University, came to Baltimore at the age of twenty-five, married Eleanor Rogers and went to live on the land that he was to call Auchentorlie. Nicholas Rogers studied at Glasgow University, returned to Baltimore at the age of twenty-five, married Eleanor Buchanan five years later and went to live on the land called Auchentorlie. Each man built his own version of a castle on this land. Although their designs differed greatly from castle to mansion house, each saw his home placed on the same "oak covered hill."

The Eye of Nicholas Rogers

Colonel Nicholas Rogers was known as a gifted lover of landscape design as well as having talent as an architect. Sometime during the American Revolution or shortly thereafter, the Buchanan "castle" burned down. As a man of action and self-confidence, as well as prowess and learning as an architect, Nicholas Rogers drew up the new plans himself. Sometime between his marriage in 1783 and 1796, the house was built in the same location as the former Buchanan castle. Having created his own home and designed his own space, Nicholas Rogers appears to have made the decision to christen the estate Druid Hill to reflect his own vision and sentiment. Although records are scarce, consensus gives the impression that at this time the name of the estate was changed.

During his time in Scotland, Nicholas Rogers may have heard or read about the Druids and their veneration for nature and, in particular, oaks, tops of hills and certain groves of trees. The Druids were the priests, magistrates, legal advisors and sages of the old polytheistic Celtic societies. They held high status and were greatly revered. The oaks held special powers for the Druids. In the courtyard square of ancient Celtic clans, an oak was traditionally planted. It served as a totem of the clan and represented the spirit and physical well-being of the clan itself. For a rival clan to attack the tree and desecrate or cut down the oak was a symbol of victory and utter demoralization of the victims. The Rogers estate was full of oaks, hills and groves, and thus "Druid Hill" was an appropriate name.

In addition to the renaming, Rogers also was responsible for much of the organized planting and landscape design around the estate. He planted trees according to their fall colors and beauty, placing evergreens near oaks and maples near cypress. His green

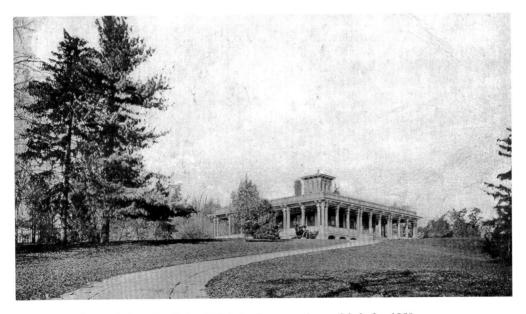

The mansion house, designed by Colonel Nicholas Rogers and remodeled after 1860.

thumb was so prolific that glorious autumns would be seen for generations. Some of these trees still thrive in the park, as do their offspring and offspring of offspring.

Socially and financially, Colonel Nicholas Rogers did well for himself. Riding on his own Revolutionary coattails, he was given the honorary rank of colonel for his services to Silas Deane and his work during the war. He must have traveled in an elite social circle because in an excerpt from one of George Washington's diaries on August 28, 1786, Washington notes a breakfast visit from Colonel and Mrs. Rogers.

Rogers became a member of the City Council, judge of the Orphans Court, a justice of the Criminal Court and a member of the Committee of Defense. He was a success in many ways and was regarded as a man of the city. However, his luck did not extend to his success as a homebuilder. On a night in August 1796, the Druid Hill mansion burned to the ground. In the house, along with most of the family's belongings, were the plans for the new home he had worked on so diligently. Luckily, the family owned other properties around town, including a home downtown. With their two children—Lloyd Nicholas, nine, and Harriet, seven—Eleanor and Nicholas Rogers moved into their temporary home. During this time, undaunted by the loss of the house or the plans, Nicholas Rogers went about designing a new and apparently grander home to be built for his family on Druid Hill.

However, in 1801, there was another disaster at the Rogers family residence. The house in which they were living at Baltimore and Light Streets caught fire in the night. It was reported that Eleanor Rogers was only able to save a silver teapot and two silver spoons that were part of the table setting that had been laid that night, awaiting the family breakfast in the morning. She had apparently grabbed them as she ran from the burning house.

So the Rogers family returned, albeit prematurely, to their estate. Luckily, the central part of the house was finished. The majestic house that Nicholas Rogers had designed, with a square center unit and two wings, was not, according to his lost plans, complete. Once again, Nicholas's plans had been destroyed in the fire (as were all other family records, including the date and explanation of the renaming of the estate) along with, perhaps, his zeal for recreating designs and redrawing plans. The addition of the two wings never came to be and the family mansion stands today as one large square structure.

Lloyd Nicholas Is Handed the Reins

On February 18, 1807, Harriet Rogers, daughter of Nicholas IV, then eighteen, was married at her family home on Druid Hill. Her brother, Lloyd Nicholas, who was two years older than Harriet, would not marry for another ten years, until he was thirty. It was Lloyd Nicholas who lived on the estate after the passing of his parents.

Harriet and Lloyd's mother, Eleanor "Elea" Rogers, died at the age of fifty-four on January 7, 1812, leaving her husband, Nicholas, a devastated widower. He never remarried and lived for another ten years at Druid Hill. At the time of his wife's death,

Nicholas made out his will. Perhaps this was out of grief or the sudden awareness of his own mortality, or perhaps he needed to amend the will with his wife's passing. In this new document, he left everything to Lloyd Nicholas Rogers, except for bequests to his daughter. Druid Hill, and all that went with it, was to go solely to his son.

Over fifty years before the Civil War, in a part of the country that would be torn apart by opposing beliefs, Nicholas Rogers set all of his slaves free in his last will and testament. He clearly knew them well as individuals and intended to look out for them posthumously. His will read:

> *All the young negroes now in my possession, viz: Edward: Christie: Jane and Horace, it is my will to have set free: the males thirty years of age and the females twenty-five, and the descendants of the females in a similar manner. With respect to my older negroes, Phillip and Lucy, I should wish them to be retained in my son's service at about a dollar a month, paid monthly according to good behavior. As to poor old "Phill" he must be taken care of to the last and be comfortably fed and clad—clad particularly, because in want of that he will suffer seriously.*

During his life, Colonel Nicholas Rogers had been known for his kindness as a gentleman and a neighbor. He allowed children to play on his estate and was a friendly face to those nearby. In his will, he included gestures of his generosity to the Baltimore Library Company, the Benevolent Charity School and the Widow's Fund of the Episcopal Society. To each of these organizations he asked that his son give a plot of land.

In the spring of 1817, thirty-year-old Lloyd Nicholas Rogers married twenty-year-old Eliza Law. Eliza was the daughter of Thomas Law and Elizabeth Parke Custis Law, granddaughter of Martha Custis Washington and step-granddaughter of George Washington. She was also the granddaughter of Edmund Law, Lord Bishop of Carlisle, and grandniece of Edward Law, Lord Chancellor of England. The couple lived on the Druid Hill estate, along with Colonel Nicholas Rogers. Lloyd and Eliza had two children, the first apparently within a year of their marriage and the second very close behind. Their first was a daughter whom they named (yes, it is true) Eleanor. Their son, Edmund Law Rogers, was born in 1818.

Colonel Nicholas Rogers lived to see his young grandchildren and perhaps enjoy their first smiles, first words, first steps and loving embraces. But this would be all he would share with them. Nicholas Rogers died on January 2, 1822. He was buried in the family cemetery next to his wife, Eleanor. The sorrow that Lloyd Nicholas Rogers may have felt over the loss of his father must have surely been eclipsed by the loss, only a few short months after, of his young wife, Elizabeth Law Rogers. She, too, is buried on the hill in the family burial plot. Lloyd Nicholas did not remarry for seven years.

On July 14, 1829, Lloyd Nicholas Rogers married Miss Hortensia Monroe Hay. Miss Hay was the daughter of a prominent judge and the granddaughter of President James Monroe (fifth president of the United States, author of the Monroe Doctrine, fourth

Virginian to hold the office of president and the third to die on the Fourth of July). The couple was married at Oak Hill, the Monroe residential estate in Leesburg, Virginia. Hortensia was named after her godmother, Hortense de Beauharnais, Queen of Holland. (Hortense's mother, Josephine Tascher de la Pagerie, was married for a second time to Napoleon Bonaparte. Hortense would later marry Napoleon's brother, Louis. This is one more connection Baltimore has with Napoleon Bonaparte. The renowned beauty Betsy Patterson married Napoleon's other brother, Jerome, although Napoleon later had the marriage annulled.)

Lloyd Nicholas Rogers and Hortensia Monroe Hay Rogers had three daughters: Harriet, Hortensia and Mary Custis. The four girls (his daughter Eleanor by his first marriage included) and his son, Edmund, were raised at Druid Hill. Lloyd Nicholas seemed content in his early days as proprietor of his family's estate, practicing law and attending to his family. Private letters and newspaper articles from the time depict Druid Hill as venue to a host of festive social events and functions. From all accounts of these years at Druid Hill, life seemed to have been full of joy and family warmth.

Time moved on, however, and a change began to take place. Lloyd Nicholas's wife, Hortensia, died in the 1850s. This event seems to have marked the dark ages in the life of Lloyd Nicholas Rogers. All of his children married and moved on, except Eleanor, his oldest daughter. Eleanor was a devoted attendant to her father until his death. She did not marry until 1862.

The Last of the Rogerses/Buchanans

The man who had been known as a positive contributor to social life in Baltimore became a curmudgeon with the passing years. There exists a bust of Lloyd Nicholas that shows how handsome he had been in his younger years. Unlike his father, who had been known as a friendly welcomer to passersby and children, Lloyd Nicholas was known to drive youngsters from his land in his later years, waving his walking stick and threatening them with his cane. He had not the graciousness of his father or the humanity. He did not share his father's position on slavery and he did not attend to the rights of his slaves as his father had in freeing them. He listed his slaves among his property and considered them slaves for life and referred to them that way in his will. He was known to be inflexible, cantankerous and stubborn. On one occasion, upon being shown his error, he remarked, "Sir, when I am wrong, I am right." But it was this man, Lloyd Nicholas Rogers, whose ill humor, gloomy countenance and fierce proprietorship of his land became his hallmark—it was this man who ended 144 years of residency. It was with this man that the generations of Rogerses/Buchanans who presided over Druid Hill came to an end.

It should be noted that, although the land was no longer in the hands of the Rogers/ Buchanan family, members of this family continued to play a part in Baltimore life. George Buchanan's grandson, also George Buchanan (son of Andrew and neighbor

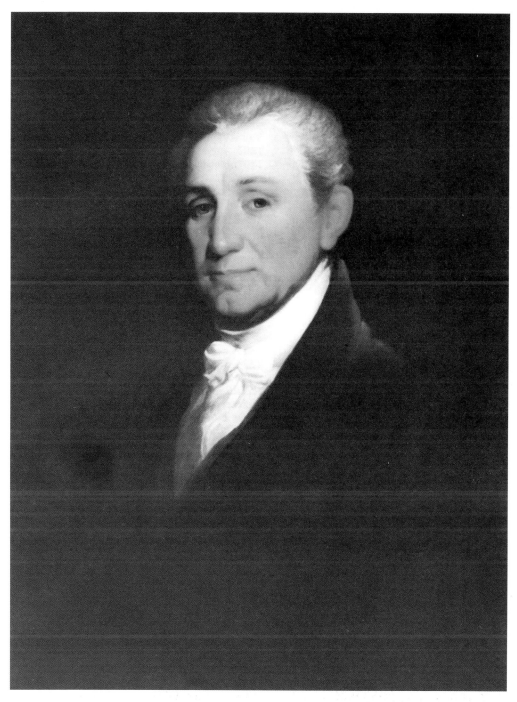

President James Monroe.

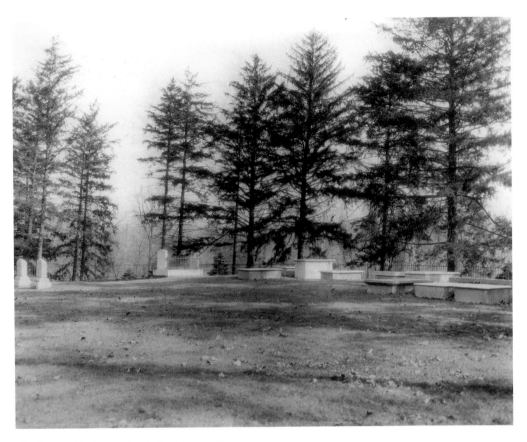

The Rogers/Buchanan family burial ground.

Rachael Lawson), established the Humane Society of Baltimore, founded the Medical and Chirurgical Faculty of Maryland and, coincidentally, was a big proponent of the creation of a public park before the end of the eighteenth century. Also, Lloyd Nicholas's son, Edmund Law Rogers, was a Harvard graduate and, among other things, is credited as the designer of Pimlico Racetrack.

THE BIRTH OF DRUID HILL PARK

Swann's Song

History tends to be generous to some while it vilifies others. History creates heroes and villains to fit into its dynamic sagas. Druid Hill Park can claim many such combined figures in its own story. Thomas Swann, without a doubt, was one of them.

Thomas Swann (circa 1806 [some resources say 1809]–1883) was indeed seen as both a hero and villain. His gifts to Baltimore City cannot be discounted, although some of his behavior might not reflect such benevolence. His reign as mayor included some of the most corrupt, tainted and bloodiest scenes in the city's—even the state's—history.

Swann was born in Alexandria, Virginia (which at that time was part of Washington, D.C.), and went to the Columbia College prep school. In 1826 he went to the University of Virginia, where he studied for one year, and then apprenticed at his father's law office. President Jackson assigned him the job of secretary to the commission to Naples in 1833. He returned the following year and married Elizabeth Gilmor Sherlock of Baltimore, moving to the city to engage in business. There he became the president of Baltimore & Ohio Railroad (B&O) and served as director in 1847, acquiring much stock in the company and thus power as well. In 1848 he became president of the company, overseeing the extension of the rail through some two hundred miles of territory to reach the Ohio River. In 1853, he resigned to take the presidency of the Northwestern Virginia Railroad (subsequently part of B&O).

In 1856, amid what can only be considered terrorism, Swann was elected mayor of Baltimore. He ran as a member of the Native American Party or, as most people know it now, the Know-Nothing Party. (Although he supported Lincoln and had, by the onset of the Civil War, freed his own numerous slaves, he sided with the Maryland Democrats against the Radical Republicans and gained the support of Southern sympathizers who elected him to the U.S. Senate, a post that he ultimately declined.) The presidential election of 1856 (with over 78 percent voter turnout) was heated and angry. The issues of slavery and immigration were causes of great consternation. The Plug Uglies (often

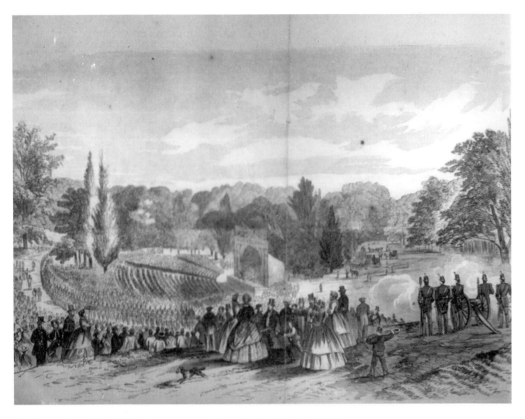

An illustration of the dedication ceremony from *Leslies Magazine*, 1860.

thought to be a New York gang, but originally a Baltimore gang) and other rowdies caused problems in the streets. Swann was said to have ignored then–Maryland Governor Thomas Ligon's request for help in abating violence during the presidential election. A year later, during the elections of 1857, Ligon put Baltimore under martial law. In 1858, Swann was reelected for his second term as mayor amid turmoil and chaos, not to mention bullying and bloodshed.

It was also during his second term, although planning and discussions had occurred for years prior, that the creation of Baltimore's first public park was put into action.

The American Parks Movement Comes to Baltimore

"A family picnic in a large park like Druid Hill is (neighborly) pleasure. And it is the most valuable in its restfulness and refreshment that can be afforded in a social way to tired city workers."

–from Olmsted Brothers
"Report Upon the Development of Public Grounds for Greater Baltimore"

In the middle of the nineteenth century there was a groundswell of support for large parks in the urban centers of the United States; it came to be called the American Parks Movement. By the mid-nineteenth century, cities such as Baltimore, New York, Philadelphia and Boston became increasingly crowded, unhealthy and stressful places to live. At that time, the public open spaces in Baltimore were limited to residential squares that were the outcome of efforts by developers or city government to spur residential development adjoining the squares (Mount Vernon Place is Baltimore's finest example).

In response to the crowded and oppressive conditions, civic leaders engaged in dialogue about how to offset these pressures. In New York, such talent as William Cullen Bryant (writer and editor of the *New York Evening Post*) and Andrew Jackson Downing (prominent landscape designer and editor of the popular magazine the *Horticulturist*) as well as Frederick Law Olmsted (at that time a writer with strong sentiments toward social reform) advocated for a large urban park in New York City. In Baltimore, Mayor Swann and others promoted the idea of a grand green boulevard surrounding the city, with carriageways, benches and landscaping.

The conversations about the need for large public parks adorning our cities were strongly influenced by the example found abroad by traveling Americans. In nineteenth-century England two trends came together that were eventually transplanted to American cities: the English country landscape style and the social reform movement. Beginning in the eighteenth century, designers of the romantic English country landscape tradition crafted bucolic scenes from the landscape of large private estates. Later, a social reform movement took place in England in response to the living conditions of the working class during the industrial development of urban centers. Ultimately, by an act of Parliament, land was purchased for England's first public park. It was a place where people could enjoy clean air and open land. The two forces—one aesthetic the other socially progressive policy—merged in one grand project.

Birkenhead Park, near the industrial center of Liverpool, was England's first large public park. Designed by Joseph Paxton in 1844, in the English country landscape style, it included an engineered countryside of meadows, man-made hills, valleys, lakes and an occasional romantic architectural feature. In 1850, while visiting the park, Frederick Law Olmsted remarked, "I was ready to admit that in democratic America there was nothing to be thought of as comparable with this people's garden." Later, in 1858, Olmsted designed Central Park, the United States' first large urban country landscape park.

Resolution No. 277

In the mid-1800s, Mayor Thomas Swann provided the leadership that was a major turning point in financing the Baltimore park system. The purchase of Druid Hill was financed through the implementation of an innovative idea, unique to Baltimore. During Swann's administration, there was intense competition for the award of a horse-drawn railway franchise in Baltimore. Mayor Swann stipulated that no such franchise would be

granted unless 20 percent of the gross income of the railway was paid to the city, for use in carrying out the boulevard plan or providing other public open space. Although this became known as the "park tax," it was not a tax on the rail companies or their riders. It was a consideration granted by the city as part of the contract agreement with the rail companies. In 1859, Ordinance 44 was approved, granting a railway franchise with the provision that one-fifth of the gross receipts accruing from passenger travel would be paid to the city to establish and maintain Baltimore's early park system. This financing scheme was very successful and was a source of national attention. Later, in 1874, the state reduced the park "tax" from one-fifth to 12 percent of gross receipts, and by 1882 it was reduced to 9 percent and again in 1932 to 3 percent. Today, it is only an interesting footnote in Baltimore's history.

Swann, despite what dubious exploits he was renowned for, was without a doubt the father of parks in Baltimore. Once the sum of $40,000 had been received by the city from the railways, he went ahead and appointed John H.B. Latrobe (inventor, lawyer, poet and artist), Robert Leslie, William Hooper (mill owner) and Columbus O'Donnell as commissioners to procure land for a public park. Along with Swann (the resolution stated that all subsequent mayors would be on the commission ex officio), these four men set about finding a site. Latrobe had been rallying for a public park since 1851 and served as president of the Park Commission until his death in 1891. With a scheme of "Public Park Stock" and revenue from the passenger railway, finances were set up for the purchase, maintenance, improvement and general running of the new space.

So it was that Resolution No. 277 was approved on the fourth day of June 1860. On June 15, the commission placed an advertisement in several local daily papers requesting "proposals…from parties willing to dispose of their property for a public park." The proposed property was requested to be a minimum of five hundred acres. Among the sites that came up as available were farm property owned by Mayor Swann and properties on York Road and Charles Street, among others. None of these properties seemed to fulfill the dream of a splendid bucolic landscape. One space, however, was idyllic. Proximity to the city (this area was not annexed into Baltimore City until 1881) in addition to its splendor made the land a must for Swann's dream. It was decided among the commissioners that nothing could compare to the property known as Druid Hill.

Changing of the Guards

Lloyd Nicholas Rogers must have seen Swann's advertisement around the same time that he lost a dispute with the Green Spring Avenue Company to secure a right of way through Druid Hill. The company wished to construct a turnpike from North Avenue to Baltimore County, cutting through the middle of Rogers's pear orchard. This defeat may have been Rogers's final impetus to sell and the timing was right for the city.

Dealing with this grumpy old man could not have been pleasant for the officers in charge of purchasing Druid Hill. Lloyd Nicholas Rogers changed his mind during the process and decided, at one point, not to sell. One reason was that the city was not

authorized to issue bonds for any improvements outside city limits. A suit was brought to court and the issue was resolved. After the "sale" had gone through, the *Baltimore Sun* printed accusations of treachery on the part of the mayor. The manner in which "negotiations" were conducted provided ample evidence for such claims. Threats to build the turnpike, a court order to restrain Rogers from touching anything on his property (no cutting trees or landscaping) as well as other bullying tactics "amicably" convinced Lloyd Nicholas Rogers that he should, in fact, sell. Great consternation continued, up until the day of the ceremony, as to the legality and ethical behavior regarding the sale of the estate. Still, with the resolution passed and the determination of Swann, there would be no stopping the purchase. For Swann, it would seem, the ends always justified the means.

For the land of his forebears, Lloyd Nicholas Rogers received $121,000.06 plus approximately $363,000 in City of Baltimore stock. The bonds were purchased by several leading citizens, including George S. Brown, a successful banker and large-scale real estate venture capitalist who built the largest number of $2\frac{1}{2}$-story houses in Federal Hill between 1835 and 1845; Philip Thomas, founder of the Baltimore & Ohio Railroad; John S. Gittings, a merchant; Thomas Winans, an engineer and inventor who went to Russia with George Whistler (the artist James's father) to organize railroads for the czar and served as director of B&O; and Chauncey Brooks, B&O railroad president and mayor-elect. All of these men were friends or former colleagues of Swann from his time on the railroad. A mortgage was given in the unlikely event that the legislature was unsuccessful in confirming the purchase. On September 27, 1860, all of the papers, contracts and binding documents were signed and Druid Hill Park became Baltimore's first public park. Lloyd Rogers did make one stipulation in the contracts. Rogers retained, in the name of the Rogers/Buchanan family, one plot of land on the Druid Hill estate. This was the family cemetery. To this day, and in perpetuity, as was requested by Lloyd Nicholas, the land is maintained by the city but is said to be owned by the Rogers/Buchanan family. It should be noted that Druid Hill Park is reported to have three cemeteries. Another plot excluded from the sale was what is now known as St. Paul's Lutheran Cemetery (see Part Three). In addition to the known cemeteries, it has been claimed for many years that there is also an unmarked slave graveyard on the grounds. Reported to be near the mansion hill, this graveyard has yet to be found.

The Greening of Baltimore

This was a very exciting time in Baltimore and the city was not alone in striving to become a better place. Much was happening around the United States as Baltimore was finding itself at the brink of great aesthetic improvements. The previous year, George Peabody had added $200,000 to his generous offerings aimed at the creation of the Peabody Institute. On November 6, 1860, weeks after the Druid Hill Park ceremonial event, Abraham Lincoln would be elected president. Foundations and organizations aimed at helping the needy, creating better space for the urban young and supporting the

The famed Philosopher's Walk.

needs of the multitude were on the brink of activity. The creation of public urban green space was to bring nature to those who could neither afford it nor afford to travel to it. Baltimore was to have Druid Hill, the third oldest established park in the United States after Central Park in New York and Fairmont Park in Philadelphia. Swann's acquisition of the Druid Hill estate not only put a feather in his cap, but it also began the move toward a greener Baltimore and Druid Hill Park would have plenty of space for all.

The October Ceremony

After 144 years, the proprietorship of Druid Hill Park came to an end. What was the Rogers family's loss became Baltimore's gain. A grand ceremony was held at Druid Hill the same year that Baltimore held a meeting of Whig and American Party members to form what was then called the Constitution Party.

On October 19, 1860, Lloyd Nicholas Rogers and his daughter Eleanor watched from their porch as the enormous festivities began. After the battles he fought over selling his

land, this would, in fact, be his farewell. Beneath the house, in the cellars, were gallons upon gallons of fine spirits: 10 gallons of the best cognac, 4 of peach brandy, 190 gallons of Madeira, over 300 bottles of wine as well as gallons of rum, sherry and Colmenar. Lloyd Nicholas planned to take these with him, as the city had no claim to this vast collection. Still, the alcohol was not enough to drown his sorrows. Whether it was out of heartbreak for his loss or just that he had given up his will to go on, Lloyd Nicholas Rogers died on November 19, 1860, exactly one month to the day after the ceremony at Druid Hill.

The mayor, though, was rejoicing on that day. It was his show, his stage and now, his turf. But, typical of Thomas Swann's affairs, the plans for the celebration at Druid Hill Park were not without discord. There was still some concern about the sale of the property and cause for ire on the part of certain organizations expected to participate. The original date for the ceremony was October 8. The newspaper declared that many groups, including the Freemasons, Odd-Fellows and the U.S. military, among others, refused to participate. Believing this to be a politically motivated denial, reports came in that these refusals were false and that there would be participation. The date was going to be difficult for certain groups but, as it turned out, there was rain and the date was changed. Since October 19 was the anniversary of the Battle of Yorktown (actually, the anniversary of the signing of papers at Cornwallis's surrender) and there was a parade and other activities planned for that event, the city and the military decided to combine the two. In the end, it was reported to be the finest military display in Baltimore history.

A parade through town ending at Druid Hill Park kicked off the events of the day. The arched gateway on Madison Avenue was crowded with pedestrians, buggies, horses and carriages. People entered and continued toward the mansion house hill. Decorations, bouquets and flags were set on display across the hill below the mansion house. A speakers' table was set with "monster bouquets" on either side of the desk. Amid the autumn color of Nicholas Rogers's trees, the sounds of the military band filled the air. By 11:00 a.m. it was reported that between eight and ten thousand people were in the park.

Ceremonies began at noon and people thronged to the front of the speakers' table. Reverend George D. Cummins, a notable clergyman, gave the opening speech and prayer. William Hayward, Esquire, introduced Mayor Swann, who proceeded, in typical Swann form, to talk for well over an hour. He spoke of the great parks of Europe and those in the United States and concluded, again in typical Swann modesty, that Druid Hill was the best of them all.

Druid Hill is one of the most ancient estates in Maryland, having been settled at a very early period of our colonial history…some of these [oaks]…bear the evidence of great age, and have been appropriately named. One of them, the "King of the Forest," a rock chestnut oak, stands on the highest pinnacle of land on the top of "Sugar Loaf Hill," and commands a view of the entire property and the adjacent country and Bay for miles around.

In addition to all of the participants and visitors, approximately two hundred schoolchildren were present at the inauguration event. It was not unusual for John Hazelhurst (J.H.B.) Latrobe to find himself at the center of some excitement and to have contributed his artistic hand. (His father, Benjamin Henry Latrobe, was also an artist and architect, famous for his work on Jefferson's White House plans from 1801 to 1817. J.H.B.'s son, Ferdinand Claiborne Latrobe, was seven times mayor of Baltimore.) J.H.B. Latrobe was a successful lawyer, had training as an architect and was known to be both a poet and an artist. He drafted the charter for the Baltimore & Ohio Railroad and had begun writing a book on law before he was even admitted to the bar. He was also on the committee that gave an award to Edgar Allan Poe and he served on the Academy of Arts. Swann had Latrobe on the Park Commission. Commissioner J.H.B. Latrobe's song commemorating the event was sung that afternoon by Baltimore schoolchildren.

We come from the city here column
On column arise to the dead:
And here, under arches more solemn
Than man ever reared, do we tread
Where the Indian once sat in council,
Or pursued the affrighted deer,
Through these woods whose autumnal glory
Is the crown of the waning year.

Cathedrals are there in the distance,
There are ships from remotest seas,
There enterprise garners in triumphs.
But where are the trophies like these?
What tint like the dogwood's deep crimson,
What vies with the hickory's hue,
What finds in the realms of the Old World,
The fall-painted hills of the new?

Lost race of the fierce Susquehanna—
Now unknown but in sounding name—
Lost tribes of the gallant "Six Nations,"
These thickets once harbored your game.
Here, of old, resounded your war-cry,
Here were rites of Mondawmin paid—
But, now, where you battled and feasted,
These throngs upon throngs are arrayed.

The branches that whisper above us,
So whispered in centuries old,
When the zephyr's soft-spoken traditions

From age unto ages were told,
As their tale is, today, of the red man,
So shall be their future theme,
While breathing life's current and eddies,
Or floating, dead leaves, on the stream.

From mansions, or costly or humble,
We have come to these woodland homes;
For the Park of the Hill of the Druid
Have forsaken yon distant homes—
That here, unto health and to pleasure,
With song and with joyous acclaim,
These forest-clad hills be devoted
By their old and ancestral name.

The *Baltimore Sun* gave a scathing review of the events and accused Swann of being wholly self-serving and acting without concern for the citizens of Baltimore. The report claimed that the park was but a luxury for a town that had greater needs than green space for pleasure. The newspaper used Swann's closing statement as an example of his garrulous speech: "I have been enabled to make my retirement from the office which I hold by the purchase and dedication of this place of public resort, and to open at once its green fields and shady groves to use and enjoyment." Although the *Sun* was quick to condemn Baltimore to "privation and expense" as a result of the purchase, Swann was as quick to mention those who pulled from their pockets to secure the land. The taxes on the rail and the bonds used to purchase the property all point at an attempt to make the park a gift and not a burden. It is undeniable that Swann was a selfish man with great ambitions. Luckily for Baltimore, Druid Hill Park was part of his plan.

Destination: Druid Hill

Baltimore was already a hub of railroad activity by the time Druid Hill Park became public. Andrew Jackson had been the first U.S. president to ride a railroad when the Baltimore & Ohio train ran in June 1833. The B&O signed its first commercial deal in 1844. Up until 1862, the passenger railway in Baltimore ended at the city line at North Avenue, or as it was known then, Boundary Avenue. Patrons wanting to visit the park had to walk a mile. In order to provide better access to the park, in 1863, the Park Commission voted to construct a small steam railway through open fields from North to Madison Avenue. Once the rails were built, the city entered into an agreement with Baltimore City Passenger Company to operate it for one year. Initially, this was a money losing venture and the city took over the program and decided to make some improvements.

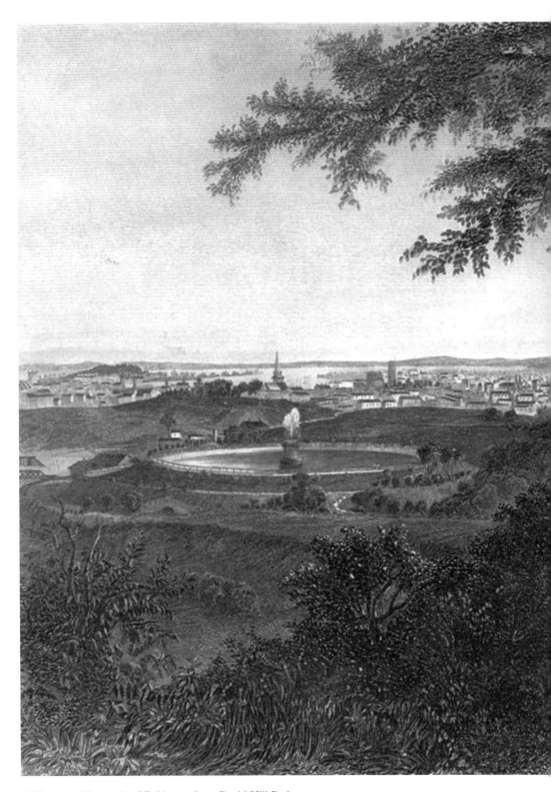

A Victorian lithograph of Baltimore from Druid Hill Park.

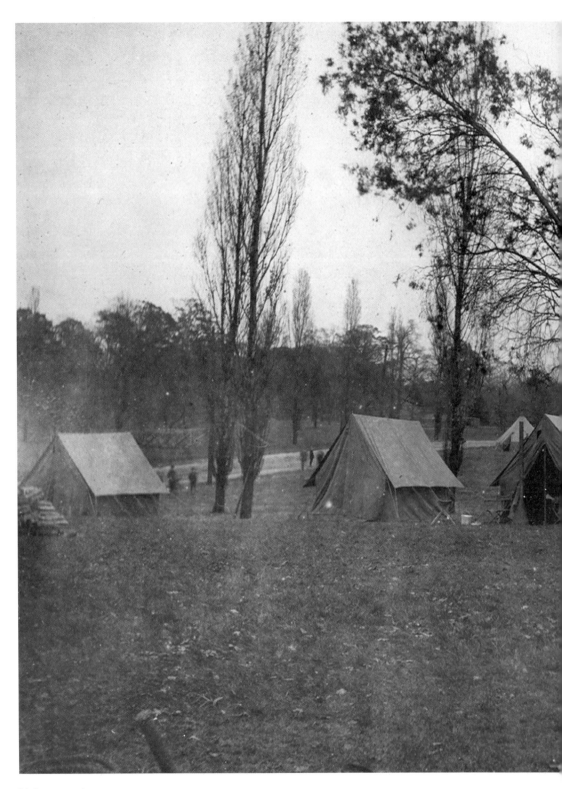

Union troops' encampment.

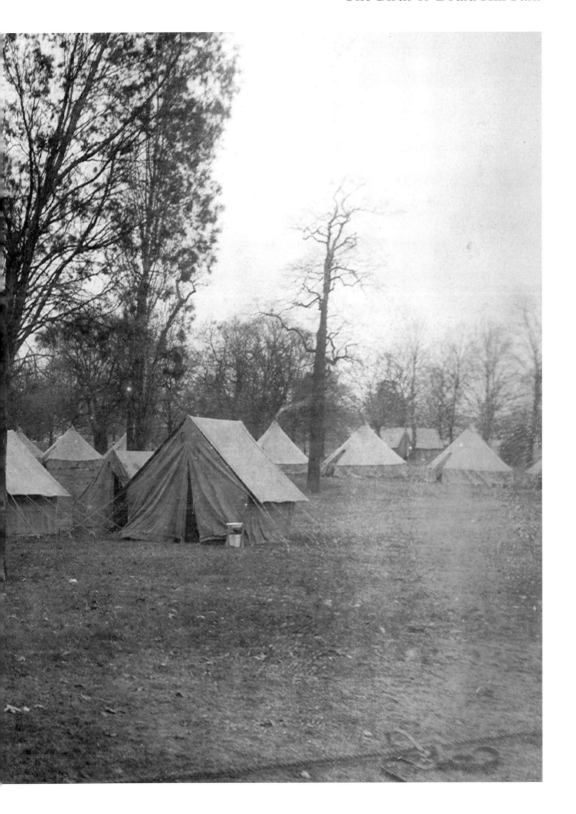

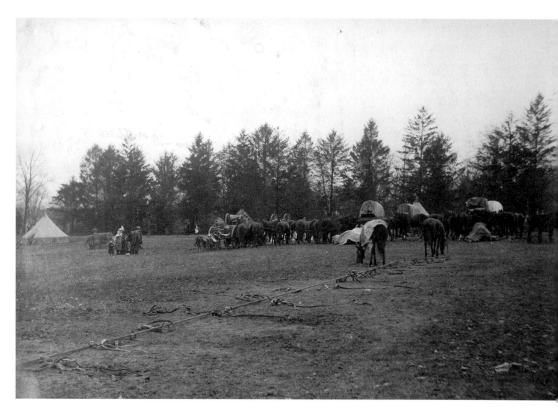

Union soldiers camped at Druid Hill Park.

This link to the park was called the "dummy line." A dummy train, dummy line or dummy engine were the names given to either a steam-powered streetcar or a passenger train streetcar that one could jump on and hold a pole or catch a seat for the ride. The phrase seems to have originated during a time of transition from exclusively horse-drawn carriages to cars with engines. There was great concern about the chaos a loud engine car could cause in startling horses and people. To remedy this problem, the boiler was covered with a passenger car body and the result was a quieter train. The term "dummy" referred to the fact that the engines were quieted, or "dummied up." These trains and later phaetons transported passengers to one of three stations inside the park.

The decision to use the locomotive train instead of the horse-drawn train was a good one. (In 1868, a line between Patterson and Druid Hill Parks boasted that their horse cars could make the trip in seventy minutes!) People were eager to ride the new trains and they soon became a source of revenue for the city, specifically for the parks. It has been noted that in 1867, revenue was $2,055.81 and over a one-week period in 1868, park visitors who arrived by rail numbered 76,000! Railways went in and out of service over the next thirty years. The city's first cable line, opened by the Baltimore Traction Company in 1891, connected Patterson and Druid Hill Parks. Later, streetcars known as the Old White Line ran from four areas of the city to the entrance of Druid Hill Park

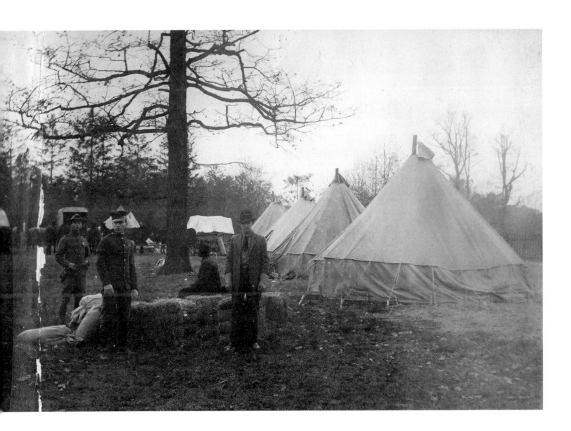

on Madison Avenue. Cable lines stopped running in 1899 and by 1935 the Baltimore Transit Company had control of all surface transportation routes in the city. Evidence of the streetcar lines can still be seen at the Madison Avenue entrance to the park.

In the 1930s the park had a bus service, but for financial reasons, in conjunction with the onset of World War II, the service was arrested. In 1946, Druid Hill inaugurated a bus service that ran at fifteen-minute intervals. Originally, the buses were merely for transportation, but the shuttle service seemed to become more of a mini tour, as some patrons preferred to enjoy the ride rather than stroll into the park. Philip Rushing, a popular driver, was known for his excellent tours. He provided information on specific points of interest while keeping to the schedule.

Druid Hill and the American Civil War

On April 19, 1861, exactly one and a half years after Druid Hill Park became Baltimore's first public park, the first shots of the American Civil War rang out. With an inner turmoil mimicking the country's own, Baltimore had families on either side of the struggle. It was a city divided. Known, among other things, as "the Gateway to the

South," Baltimore holds a dubious place in history and in the Civil War. Confederate sentiment was strong. Abraham Lincoln received only 1,100 votes of more than 30,000 cast for president in 1860.

Casualties resulting from the April 19 riot in Baltimore are considered the first bloodshed of America's Civil War. Riots resulted from the arrival of Union forces marching through Baltimore between the Camden and President Street railroad stations on their way to the capitol. Southern sympathizers and pro-secessionists rallied and attempted to prevent the troops from getting to Washington, D.C. An angry mob descended upon them, throwing rocks and screaming with verbal attacks. The soldiers panicked and fired into the crowd. At least ten soldiers and as many civilians were killed in what some called the "massacre at Baltimore." Federal leaders imposed martial law on the city.

During the Civil War no battles were fought at Druid Hill Park. But, according to the interpretive sign located at the corner of Swann Drive and Druid Park Lake Drive,

> *Within a year of the riots, the first of several U.S. Army camps and fortifications began circling Druid Hill. The area was an important location above the city and adjacent to the Northern Central railroad. The 114th and 150th NY Infantry Regiments occupied Camp Belger (Fort No 5) in Druid Hill. Named for Col. James Belger, quartermaster of the Middle Department headquartered in Baltimore in March 1862. At least 15 regiments eventually camped in the park near the entrance at Madison Avenue in the shadow of the park's main gate. In July 1963, Druid Hill became known as Camp Birney, after Secretary of War, Edwin M. Stanton assigned General William Birney, son of an abolitionist, to recruit African Americans for a U.S. Colored Troop (SSCT) regiment. Birney freed 16 shackled slaves from a Pratt Street slave pen when they promised to enlist. He also organized the 7th USCT in Druid Hill, as well as the 4th and 39th USCT's in 1864 or is it 1869.*

Artifacts from that era have been found around the site of the Howard Peter Rawlings Conservatory. Items such as buttons, belt buckles and pieces of silverware have been traced back to this period.

Even as the war was raging, plans were being made for Druid Hill Park's improvement.

Grand Designs and Master Planners

Building Baltimore's First Public Park

Whatever the concerns had been prior to the purchase of Druid Hill, the fact was that Baltimore now possessed a beautiful bit of country right in the vicinity of the city. Looking at the park, the untrained eye might imagine that little needed to be done to make this space into an urban oasis. However, the fields and the careful landscape design Nicholas Rogers had created had been left to seed in the years after his death. The estate had been "laid out in the best style of English landscape gardening" but had been "agriculturally neglected." The city searched for and hired a team that would turn this natural wonder into an accessible, pastoral destination away from the ills of urban life for its residents and visitors alike.

Druid Hill Park's topography is both beautiful and unique. The park lies on the fall line between two physiographic regions: the Piedmont Plateau and the Coastal Plain. The fall line, in essence, divides the park into two very distinct sections with different topography. The southern part of the park, from the conservatory to the reservoir, including the main recreation areas, is located on the gently undulating topography of the Coastal Plain. In the northern part of the park, the forests are situated on the steeper slopes of the hilly Piedmont and in valleys along small streams. These steep slopes prevented intensive timbering and the development of the area, with the exception of two small quarrying operations. The development of the park was influenced by this topography, giving Druid Hill Park its special beauty.

The Natural Designs of Howard Daniels

As plans were being made in the months after Druid Hill's purchase, the Park Commission hired Howard Daniels, an engineer and landscape gardener, to create walks, drives and

Mansion House Road.

lakes and to work his magic naturalizing the already resplendent acres. Daniels also served as park superintendent and he chose Druid Hill as his destination from numerous competing properties. He had worked previously in Ohio as an architect (he designed the Dayton Greek Revival–style courthouse in 1850) and landscape designer. He most likely drew attention for his proclivity for naturalizing the landscape from his work at the "rural" Spring Grove Cemetery in Cincinnati and at the tree-filled Oakwood Cemetery in Syracuse, New York. He was listed under the title "architect" when he entered the competition for New York City's Central Park. Daniels came in fourth place for his "Manhattan" plan and was given an award of merit for his design. Daniels also acted as a consultant to Matthew Vassar at Vassar College. In 1855–56, Daniels traveled and studied the parks in England and Europe, bringing his newfound knowledge back to the United States. John H.B. Latrobe, a prominent figure in the movement for public parks, made his move to hire Daniels. Latrobe had been proprietor of historic Greenmount Cemetery as well as a force in the rural cemetery movement.

In 1860, the year that the park opened to the public, Daniels wrote an article on the need and desire for bucolic spaces in urban environments. In addition to his work in the field, he was also an excellent writer and contributed to numerous publications and journals. Daniels wrote and published an article in *The Horticulturalist and Journal of*

Rural Art and Rural Taste, a publication that was founded by Andrew Jackson Downing, Daniels's and Frederick Law Olmsted's mentor. The piece, entitled "A Public Park for Baltimore," focused on growing public interest in "rural places" within the confines of cities, and specifically in Druid Hill. In the article, he writes of Druid Hill Park, "Baltimore may in a year or so have a park that will not be equaled in the world." He describes Druid Hill in loving detail:

> *Broad meadows, bordered by irregular groups of trees connected by dense thickets of wild and tangled underwood, climbers and vines feathering to the ground, and spreading irregularly into masses, which luxuriate in the most negligent abandon; the central portions enlivened by majestic old specimen trees, or small groups, form scene of great breadth and dignity, such as are to be found in the best English parks.*

Although Howard Daniels is not a recognizable name like Frederick Law Olmsted, he was well known and respected among his peers. It was his vision that played a significant part in shaping Druid Hill Park. Colonel Nicholas Rogers was Druid Hill's initial architectural designer and Daniels felt his job was to carefully guide the existing landscape while still maintaining the wildness. For his work, Howard Daniels was paid ten dollars per day.

Tragedy came to the new park, however, and an important champion was lost. In 1863, Howard Daniels, at the age of forty-nine, died after only three years on the job. It happened unexpectedly from a hemorrhage of the stomach at Eutaw House. To his credit and talent, Daniels is listed among the *Pioneers of American Landscape Design* (U.S. Department of the Interior, 1993) for designs he created that were either implemented or inspired by other designers.

In 1863, park engineer Augustus Faul took Daniels's place as superintendent. Luckily, Faul had worked closely with Daniels and continued to follow his lead, as Daniels had followed Colonel Rogers's lead toward a naturalized landscape. Both Daniels's and Faul's reports detail the features that are now so prominent in the park—the drives, the walks and the lakes. The influence that inspired Central Park's architecture can be seen in many aspects of Druid Hill Park. By 1867, Augustus Faul reported that most of the water system had been completed. The Park Commissioners considered water essential to the vision of the landscaped urban park. When the land was first purchased, the absence of water was considered Druid Hill's only liability and led to the creation of lakes and reservoirs. The springs, streams and man-made lakes became important scenic features.

Youth Finds an Architect

An important element of the landscape of the park is the design and siting of its structures; in Druid Hill only a few structures existed prior to the park and most were in disrepair. In 1862, the Park Commission hired nineteen-year-old architect George

Crow's Nest Road, from
*Artwork of Baltimore. Courtesy
of the Peabody Library.*

The park under renovation, circa 1860s. From *Artwork of Baltimore. Courtesy of the Peabody Library.*

From *Artwork of Baltimore. Courtesy of the Peabody Library.*

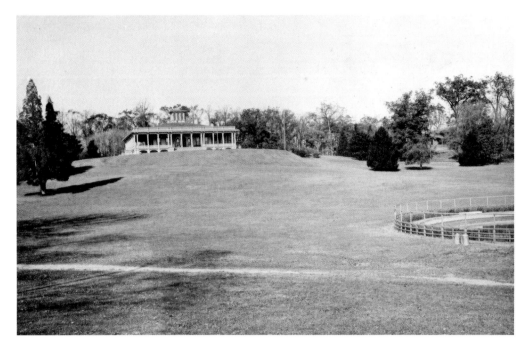

The mansion house circa 1870, from *Artwork of Baltimore. Courtesy of the Peabody Library*.

Path through Druid Hill Park, from *Artwork of Baltimore. Courtesy of the Peabody Library*.

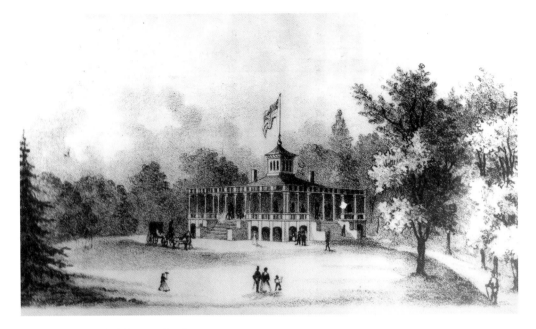

Pre-1900 postcard of the mansion house.

Aloysius Frederick to design a series of park buildings in Druid Hill Park. Although Frederick was young and not well known, Latrobe must have recognized his abilities. Frederick went on to create some of the most memorable structures in the park, although he is probably most famous for his design of City Hall (1867). He also designed Cylburn Mansion (1860s), St. Joseph's Hospital (1872) and Hutzler's Palace Building (1887), and worked with Latrobe on various projects in Patterson Park. Frederick worked for the city as an architect for thirty-three years. He died in August 1924 and was buried in the New Catholic Cemetery.

With Latrobe leading the Park Commission, architectural and artistic integrity were assured. He worked closely with the young Frederick on the design of most of the park's distinctive structures during the 1800s. Early on, plans were made to demolish most existing and inhabited structures that that had fallen into disrepair and sell forty thousand pear trees from the extensive Rogers grove. Latrobe influenced Frederick's design of the gateways to the park and alterations to the mansion, as well as the pavilions, the Moorish Bandstand (1865), the Moorish Tower (circa 1870), the Maryland Building (1876) and the Fish Hatchery. The two must have had many discussions about the architecture Latrobe had seen abroad. Many of the new structures were designed with the intent of complementing the landscape and showing exotic influences.

Frederick's first buildings were a series of pavilions and entrances using themes adapted from Asia and the Near East. Three of the six new pavilions were termini for the passenger rails that ran from North Avenue to the park. The Chinese Station (1863), located at Druid Hill and Fulton Avenues and named for the character of its architecture, was used by visitors who wanted a stroll through the woods to reach the Band Stand via the Grand

Promenade. The pavilion was relocated to Swann Drive near the George Washington statue and only part of it remains today. Orem's Way (1863) was designed by Latrobe and features Islamic arches. It was originally located near Auchentoroly Terrace and was named for John Morris Orem, who owned the nearby estate of Auchentorlie. It was also called Rotunda Station and is now known as Latrobe Pavilion. It would bring passengers nearest the Promenade and the music. It was moved to its current location just north of the reservoir later in the century and remains relatively intact. Council Grove Station (1863), the terminus of the railway, was most likely named for a nearby grove of trees, long lost to history, where Native Americans held council. The pavilion, employing Greek detailing, remains in front of the zoo. The Report of the Office of the Public Park Commission to the mayor and city council of Baltimore, dated January 1, 1865, lists the total cost of the 1⅓-mile railroad and the three stations as $25,213.35. The Council Grove Station cost $3,111.45. Other railway routes ended at park entrances on Eutaw Place, Mount Royal Avenue and Druid Hill Avenue.

In 1968, the Council Grove Station was in serious disrepair. The structure had settled unevenly, posts were rotten, the roof was full of holes and some of the decorative eave pieces had fallen off. It was decided to bring Baltimore City vocational education students to work on the repairs. Along with the Department of Recreation and Parks and the Bureau of Public Building Construction, the project was co-sponsored by Baltimore Heritage, Inc., and gifts of materials were provided by local businesses. Students ranging from fifteen to twenty-two years old built and replaced molding, scrollwork and forms of pre-cast concrete bases. Preserving this historic landmark provided students with training and understanding of architectural details. Mayor William Donald Schaefer awarded them certificates.

Additional pavilions include the Chess and Checkers Pavilion (1863)—or Sundial Pavilion—a metal structure incorporating designs of pavilions located in Paris that is now located on the west side of the lake. The Octagonal Pavilion (1863) was originally erected for the members of the Parks Board to tie up their horses while attending board meetings. It contained a cast-iron trough and stalls for eleven horses and became a peanut stand and snack bar in the zoo. In addition, there are seven historic pavilions, five umbrella style (two of which are in the zoo) and two rectangular (1890). These seven park structures were renovated in 1994 and are used most every weekend in the warmer months for picnics and family reunions.

Madison Avenue Entrance

The Tuscan Doric gateway or Etruscan Triple Arches at Madison Avenue were a stop for the horse-drawn railway and later the trolley. Modeled after European gateways and reminiscent of the Brandenburg gate in Berlin, work began in 1865 and was completed in 1868 at a cost of $24,000. The Park Commission insisted on using the austere-looking Nova Scotia sandstone rather than Baltimore marble. The arches had a rather rugged beginning. A ship was built for the express purpose of transporting the enormous

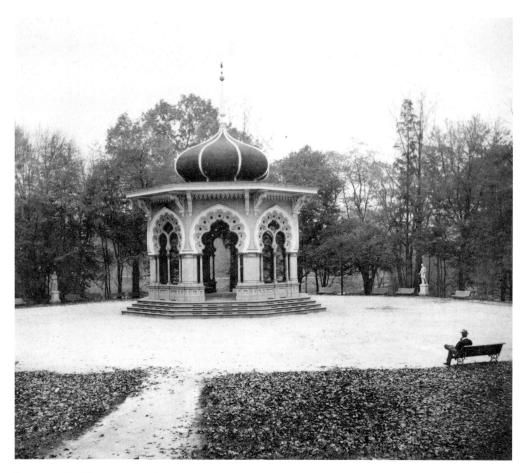

Bandstand Pavilion. *Courtesy of the Peabody Library.*

quantity of stone to Baltimore. On its return trip, the ship was lost at sea. A second ship arrived safely with the sandstone, although tragedy came in the form of a fatal accident during the construction when a worker was killed by falling stone. Wrought-iron gates once spanned between the arches and were opened each morning and closed at 9:00 p.m. In 1961, the arches were almost removed after a resident complained that they were a traffic hazard. In response, $14,000 was raised to preserve them. An upcoming restoration is planned. Additional accesses to the park, such as Cedar Avenue (now the Wyman Park Drive entrance), Greenspring Avenue, Parkdale Drive, Liberty Heights Avenue and Gwynns Falls Parkway, were designed as "exits."

Mansion House

This early Federal-style building, built as the seat of the estate in 1801, sits high on a hill. It was the third home built on the estate. The second one, designed and built by Colonel

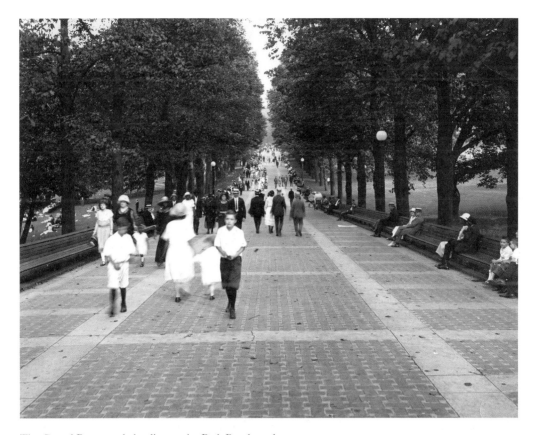

The Grand Promenade leading to the Park Bandstand.

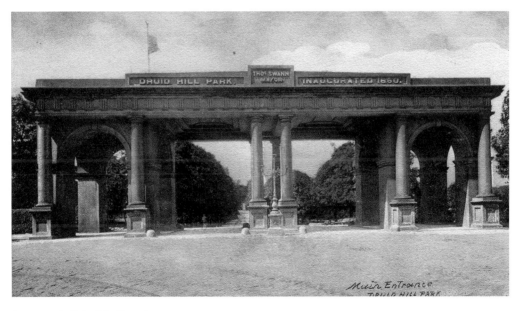

A postcard of the Madison Avenue gate.

Nicholas Rogers (1753–1822) in the late 1700s, was destroyed by fire in 1796. Two wings, planned for either side of the current mansion house, were never built. The house is similar in style to the Homewood House, the home of Charles Carroll Jr. that was built several years after the mansion house. Howard Daniels intended the mansion house and its south lawn to be the central feature of the park. In 1863, Latrobe and Frederick converted the structure into a public pavilion by adding broad ornate porches, twenty feet wide, on all four sides and constructing a refreshment arcade in the basement. The roof was raised and an Italianate tower was added. For a time at the mansion house, horse-drawn carriages could be rented for three cents. In 1935, the porch was enclosed and used as a restaurant for a short time. "Air-cooled by nature" and billed as "every man's country club in the very heart of Baltimore," it featured a modern Milk Bar, a doughnut-making machine and dining on the veranda. From the building's cupola, visitors had a wonderful view of the city. For a time the basement housed the headquarters of the park police. In the mid-1950s, the Hall of Jewels exhibit (featuring exotic birds and small mammals) opened on the mansion house porch and the building was informally nicknamed the Bird House and functioned that way for nearly thirty years. In the mid-1940s, the building was used as a day school for the Young Men's and Women's Hebrew Associations; attendance came from the Jewish population surrounding the park. Today the mansion house serves as the home to the administrative offices of the Maryland Zoo.

Mansion house with sheep, circa 1890.

The Maryland House

The Maryland House, an elaborate Stick-style frame building, was built for the 1876 Centennial Exhibition in Philadelphia. This was the first World's Fair to take place on United States soil and also marked the celebration of the one hundredth anniversary of our nation's independence. Twenty-six states and eleven nations had their own buildings named after them at the fair. The Maryland House served as the Maryland State Pavilion and as a railroad station in the transportation system at the exposition. It has been described as English Tudor and Swiss Chalet style. It was moved to Druid Hill Park where, according to the Annual Report of the Park Commission, in 1876 the Park Commissioners proposed to "place it on the eminence east of the Pavilion [mansion house] and between that and the road leading to Tempest Hill."

In the 1870s it housed the Natural History Museum, sponsored by the Maryland Academy of Science. "The building became a place of exhibition for all the 'curiosities' that had been collecting over the years in the basement rooms." One of these collections was a set of fire fighting equipment, including decorated hand pumps, one of which was said to have been given to the Friendship Fire Company of Alexandria, Virginia, by General George Washington. Part of the collection was turned over to Fort McHenry and the rest to the Maryland Historical Society. In April 1877, Otto Lugger was appointed naturalist in charge of the museum at a salary of $400 per year. A notation in the Annual Report of 1880 mentions "a handsome and increasing ornithological collection."

In 1936, after years of service as a storehouse, the Maryland House became the headquarters of the Natural History Society of Maryland and home to a museum of natural history, housing Indian artifacts, rocks, birds, animals and botanical specimens. It was absorbed into the zoo in 1967. The building was severely deteriorating and major renovations and restoration work were completed in 1978. Ceremonies on May 6 of that year celebrated the reopening and new designation as home to the Zoological Society's offices.

Additional structures designed by Frederick include the Superintendent's House (1872), "a large stone, Gothic-influenced building with decorative quoins and steep gables" located on Reisterstown Road; the Moorish arch at Garrett Bridge, a stone bridge spanning a ravine along the curve of Crow's Nest Road; and the Fish Hatchery, a filter house for the ponds.

The Shepherd of Druid Hill Park

One of the early hires at the park, circa 1869, was a shepherd whose flock of Southdown sheep would tend to the lawns. The first shepherd was a Scotsman who was soon replaced by George Standish McCleary, or "Mr. Mac," as he was known. McCleary had migrated from Virginia to Hampden and remained as shepherd in Druid Hill for many decades. Children would join his flock, helping to catch and trim the sheep, nurse

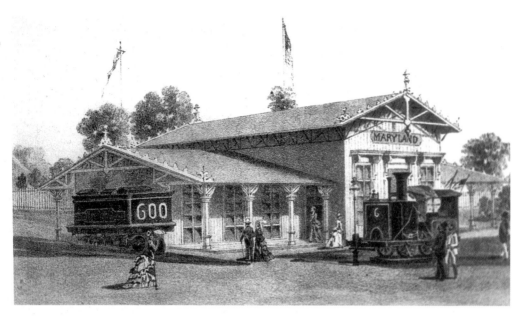

The Maryland Building, as it was after being rebuilt in Druid Hill Park after the Centennial World's Fair in 1876.

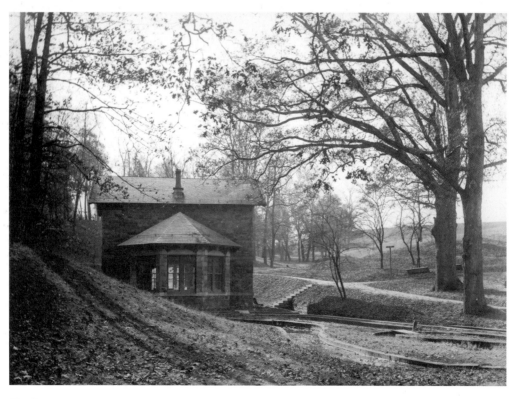

The Fish Hatchery, designed by George Aloysius Frederick.

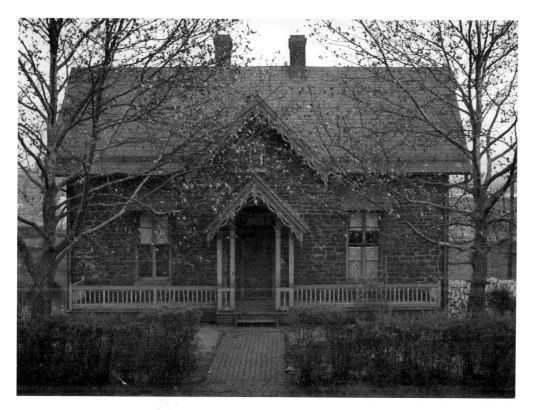

Park keeper's house, 1936.

new lambs and simply enjoy being in the company of the city's own shepherd. With his snow white beard and great Virginian accent, he was known to walk from his Hampden home, across the Cedar Avenue Bridge, up to the fields (behind where the pool would be built) to his sheepfold. There was no freeway and not much traffic, so his was a rural walk. It was said in an editorial article by Malcom Lowenstein (who had been a child during McCleary's tenure) in 1958 that Mr. Mac wore a footpath from his daily travels. Another fan, Manfred Guttmacher, who considered himself a former student of Mac's, wrote, "[McCleary] exerted a greater and better influence than any teacher we ever had." Guttmacher thought of Mr. Mac as something of a mystic and a philosopher.

Mr. Mac was fiercely dedicated to all of his charges, both sheep and children alike. He was reliable and committed to his work, sometimes leaving his wife and family (he had ten children) at 4:00 a.m. and not returning until 8:00 p.m., or staying all night if a ewe was giving birth. Lowenstein says that he went every day after school and spent the weekends helping with Mr. Mac's sheep. Mr. Mac would tell stories of life as a shepherd and of his days cattle rustling for the Confederates during the Civil War. He had three Scotch collies to help him tend the sheep and was said to speak gently to them and they would immediately respond. He could ask politely for Mollie to go and fetch a particular sheep and, according to park lore, the dog would do it. He was known to buy medicine for his sheep out of his own pocket money, which must have been wanting. He was

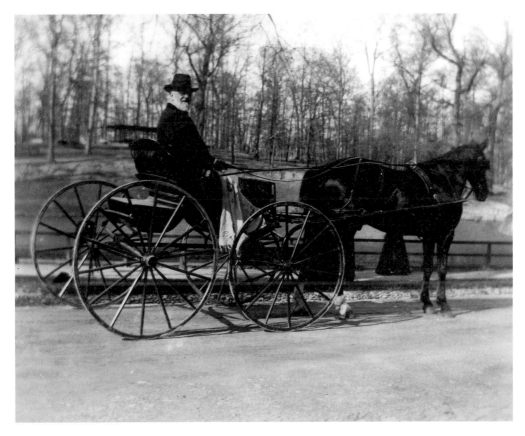

Above: William H. Cassell.

Opposite above: Young McCleary.

Opposite below: An older George Standish McCleary.

known to love children and be a warm and receptive host to all visitors. He retired in 1926, fearing only that his successor might not love his sheep or his people as much as he had.

This, however, would not be the case. C. Edward Bowersox held the position until April 1, 1937, when he turned seventy and, forced by regulation, retired. His sorrow at leaving was equal to that of Mr. Mac. He cried when interviewed at the close of his tenure, pointing out the sheep who were his favorites, including one named Martha Washington. The position was then taken up by William Forrest Turnbaugh, who had been a laborer at Carroll Park making forty cents per hour. He had been raised on a sheep farm, had an elementary education and three years' experience with sheep. By 1945, the sheep were contained and no shepherd was employed. Turnbaugh apparently quit some time during the war and the administration was unable to find a replacement.

Superintendent of the Park

Captain William Henry Cassell was superintendent of Druid Hill Park for thirty-seven years. He had been a Secret Service agent during the American Civil War and was appointed to his position at the park in the latter part of the nineteenth century. He was known to cruise the park in a buggy pulled by his white horse, Ned. In the winters, when there were no automobiles and therefore no reason to clear roads, Cassell would ride around the park on a horse-drawn sleigh. Captain Cassell fulfilled his duties until his death in 1904.

Chapter 5.

BALTIMORE'S ZOOLOGICAL PARK

The Zoo's Earliest Days

When does a zoo become a zoo? With the Maryland Zoo in Baltimore (formerly the Baltimore Zoo), the answer isn't exact. Officially, the zoo was opened in April of 1876 by an act of the Maryland General Assembly authorizing the Park Commission to "form a zoological collection within the limits of Druid Hill Park for the purpose of public exhibition for the instruction and recreation of the people." It is (depending on when zoos were considered to be officially established) the third or fourth oldest zoo in the United States. Rare, interesting and unusual animal menageries had been en vogue since the Middles Ages and even during Roman times. Many of these private menageries grew into larger collections of caged animals put on display by private keepers for the amusement of the public, often at a charge. Over the decades, zoos evolved into public learning and conservation centers. The Tiergarten Schönbrunn in Vienna, located in the grounds of Schönbrunn Palace, was established in 1752 as the imperial menagerie. Menágerie du Jardin des Plantes in Paris was established during the Revolution in December 1794 as a new home for the four survivors of the palace menagerie at Versailles. The London Zoological Gardens opened in 1828, giving the name to the growing passion. The name "Zoological Gardens" was quickly shortened to "zoo."

The Philadelphia Zoo was formally established in 1874, followed fourteen months later by Cincinnati (plans had been made in the 1850s but were delayed because of the Civil War). Central Park purchased the Halifax Zoo, which had been the oldest zoo in North America, established in 1847. Chicago's Lincoln Park Zoo was established in 1868.

The 1860s and '70s brought great additions to Druid Hill Park. An 1865 inventory listed, according to a pamphlet by Friends of Druid Hill Park, "9 deer, 4 swans, 3 wild geese, and 24 ewes." It can be argued that this was not a menagerie, but that the sheep

were there as lawnmowers and the deer and birds ran wild. But in September 1867, Thomas Winans, a wealthy railroad designer, benefactor and member of Baltimore's elite, gave the park a gift that would mark the first collection of non-working animals. He donated a herd of 52 deer that he had raised and domesticated on his own farm in Baltimore County. The park sheep were thoroughbred Southdowns and roamed free until the coming of the automobile, when it became clear that they would be a danger to themselves as well as drivers who sped through the park. The shepherd kept a close eye on his flock with great attention for the fast moving vehicles motoring around the grounds. Although legislation in the name of the Automobile Act granted the parks the right to limit or designate areas for driving, the parks did not have the right to exclude cars altogether. Fences were built and the deer were placed within. (It should also be noted that after World War I, the uncaged deer were placed in danger from the Park Commissioners, who were said to enjoy perhaps too many feasts of fresh venison.)

Growing Population of Creatures

Starting out small, with its herds of sheep and deer, the zoo began adding exhibits to suit the interests of the locals and tourists. Originally the creatures were kept in menagerie-

First enclosures, elks, 1881.

Fawns, 1891.

style, small Victorian cages, as curiosities for interested people. There were no fences separating the zoo from the rest of the park, so casual visitors could peruse the collection at no cost and with easy access. The park was considered a beautiful site for a zoological garden and the zoo began to grow.

In 1879, a "bear pit" and monkey house were added, and in an inventory of 1880, seventeen species were listed, including thirteen monkeys, two black bears, two wolves, one tiger, one alligator and two boa constrictors. The collection even boasted ownership of the city's only three-legged duck. In 1897, another artistic member of the Latrobe family who served as the general superintendent and engineer of parks designed an elegant Victorian eagle cage. By the turn of the century, most of the exhibits were fairly near the mansion house, although the Three Sisters Ponds, north of the mansion hill, became home to the sea lions.

Gaining an Elephant, But Losing a City

Many of the animals, especially the sea lions, did not do very well in these less than adequate facilities. A pair of sea lions was apparently flown from San Francisco but at

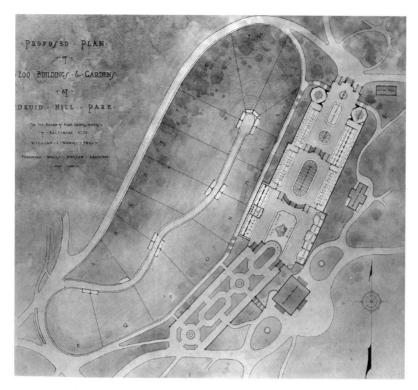

The proposed new design for the zoological gardens by the Park Commission, 1925. *Courtesy of the Department of Recreation and Parks.*

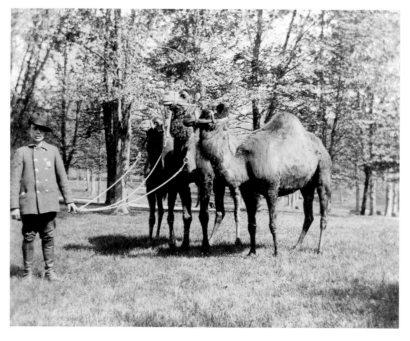

Camels, circa 1880s.

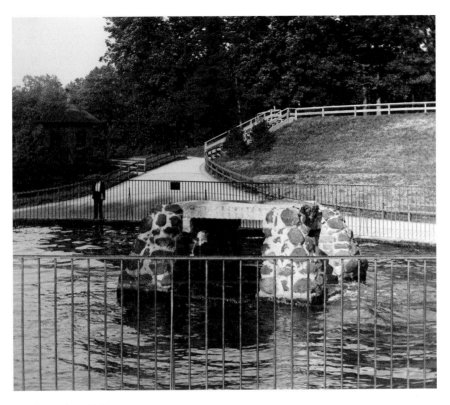

Sea lions, circa 1895.

Angora goats, 1930.

least one died immediately upon arrival. Victorian animal care left much to be desired. Animals were seen as things of curiosity and little attention was given to their natural habitat and needs as living creatures. By the early 1900s, zoo attendance began to drop. Local private zoos, with their own collections, competed for visitors and the zoo lost many of its population.

The children of Baltimore did not forget their love of the zoo entirely, however. In 1924, polar bears came to the Baltimore Zoo and in 1925, Baltimore's youngest citizens collected pennies and donated them so that the Baltimore Zoo would be able to purchase an elephant. With their help, Mary Ann found a home in Druid Hill Park. The elephant was paraded around for the proud children to see. She spent years as one of the main attractions and was a beloved member of the zoo family for more than a generation.

Zoo Revival

After World War II, the Baltimore Zoo was given the breath of life. The year 1948 brought the zoo's first permanent director. Until that point, the zoo had been managed by park employees and had not had a trained zookeeper. The zoo required a person

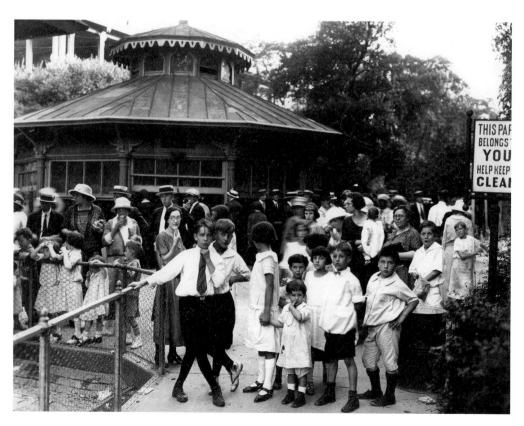

Baltimore's elephant fundraisers, circa 1925.

Mary Ann playing on the lawn, circa 1925.

who was both qualified and passionate. That person was Arthur Watson. He hosted a weekly television program called *This Is Your Zoo*, involved schools and hosted events. Watson's "traveling zoo" brought animals into classrooms and allowed for handlers to take creatures to events, bringing attention and renewed interest to the inhabitants of the neglected zoo. Watson's work was not limited to public relations, though; ameliorating and growing the collection was another serious focus of his attention. By the mid-1950s, Watson had increased both the attendance to the zoo and the collection. Under his management, the zoo was home to over one thousand animals within a few years of his arrival.

The 1960s saw even more growth. What would grow to be an award-winning Children's Zoo was created in 1963. The Giraffe House, Rock Island and a "home to the largest captive population of African penguins in North America" were built, as well as other structures. In 1970, a three-mile fence went up as part of a requirement by the U.S. Department of Agriculture, under the Animal Welfare Act. Incidents of vandalism had occurred in the years preceding the erection of the fence, and the news media drew a correlation between the two. But the primary motivation for the fence was the USDA requirement, as it provides a final barrier between an escaped animal and the general population. Importantly, the fence also prevents feral animals from gaining access to the zoo, which can be very dangerous to the captive population. The downside of the fence is the separation of the front "active" part of the park from the quiet, hilly, wooded north end. Before the erection of the fence, visitors had easier access to the entire park.

Taking Baltimore's elephant Minnie for a walk, 1942.

Sea lions, circa 1900.

Winter at the zoo, 1938.

In the 1970s, the first entrance fee of fifty cents was instituted. The 1970s also brought the Centennial Master Plan, African exhibits and a call for more naturalistic habitats. The next decade saw many of these habitats built. The zoo has undergone many transformations over the years and continues to walk the balance between retaining adequate funding and upgrading exhibits.

The Pieces that Fit

The Boat Lake

This magical pond was formed in 1865 when a stream was dammed, creating what was then called the Upper Lake, referred to as the "skating pond." The stream ran through the hollow where the small boat lake is now and then continued to a large ravine (what is now the reservoir). A charming little gingerbread house, the "Island Cottage," was built on the island in the lake (1869). This building housed a changing area and facilities for women and was used by female skaters during the winter. Many photographs and postcards can be found of multitudes of skaters on the lake in winter months. During the warmer weather, varieties of boats were seen on the pond, from miniature steamers to "Swann Velocipede Boats" like those seen in the Boston Common. Many events occurred on the boat lake over the years, some celebratory, some disastrous. On January 7, 1940, at 2:30 p.m., a fire broke out on the boat lake, terrifying visitors. The flames were fueled by a stack of rowboats and under the weight of more than one thousand skaters, the ice began to crack and melt. Chaos ensued as people tried to collect their clothes and shoes while avoiding both flames and freezing water that was seeping up through the fissures in the ice. Amazingly, no one was seriously injured.

In 1955, vandals waded across the four-foot-deep moat to the island, twenty feet from shore, and smashed the rowboats. The condition of the lake at the time made this a risky adventure for the villains. Authorities came under criticism because of the state of the boat lake, even though anti-algae chemicals were administered twice a year. For about one hundred years, the boat lake was a destination for both summer and winter fun. Families and sweethearts could be seen out for a row on warm afternoons and hoards of people, young and old, skated on the pond in the winter. (In 1955 it cost fifty cents to take a boat for a ride on the lake, the same to rent a bicycle for a ride through the park and twenty-five cents to swim in the pools. It was a time when cricket was played, there was a designated archery area and the zoo was free.) In 1958, plans were made to

Lily pond at Three Sisters Ponds, 1892.

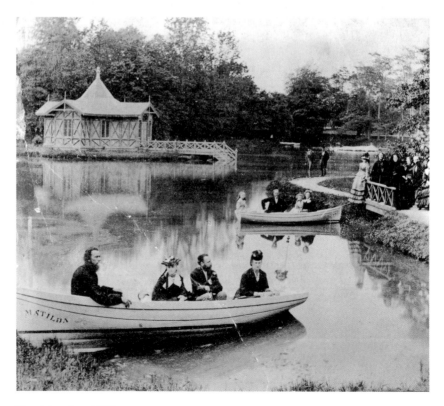

Boat lake, circa 1870.

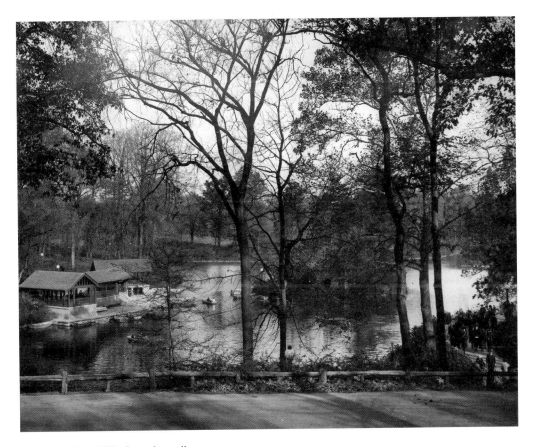

Boat lake, circa 1870, from the walk.

transform the boat lake into a bird sanctuary, and in 1959 the lake was drained and the dirt bottom was replaced with a rock bed. The lake became the zoo's waterfowl exhibit and was eventually closed.

Druid Lake

Unlike the boat lake, Druid Lake was built with the intention of having it be a significant part of the city's waterworks. Completed in 1871, the lake is approximately fifty-five acres in extent, containing 429 million gallons of water with an average depth of 30 feet. It took eight years to build and, at 119 feet tall, was the largest earthen dam built in the United States at that time. The dam was the forerunner of many earth dams built across the country and is one of many historic structures gracing the park. The reservoir area had originally been a ravine carved by a stream that ran from Edmunds Well near the boat lake into a waterfall located near the statue of Christopher Columbus (on the northwestern side of the lake), and then flowed into the Jones Falls. At the time the lake was named Lake Chapman, after the first president of the Baltimore City Water Board.

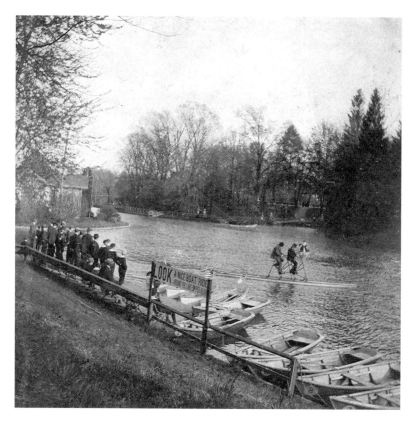

Bicycle boats on the boat lake.

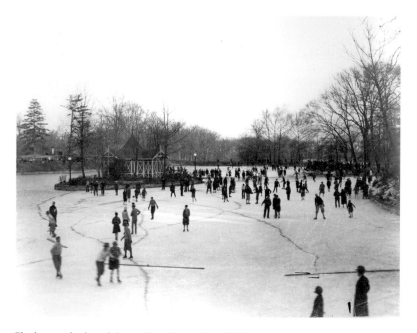

Skating on the boat lake on New Years Day, 1895.

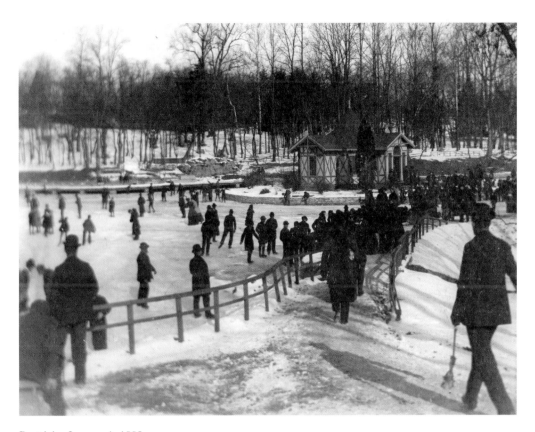

Boat lake, January 1, 1895.

Civil engineer Robert Martin supervised the dam project using steam shovels, the first ever used in Baltimore. He constructed a watertight core in the center of the dam by puddling carefully selected clay material between earth banks. These banks, as well as the rest of the earthen parts of the dam, were constructed in thin layers and carefully compacted by horse-drawn carts and heavy rollers. Concern for the safety of the structure arose after the collapse of a similar dam in England killed 250 people. The fatal collapse, however, did not staunch Martin's commitment to completing the Druid Hill dam. It was, and remains today, strong and stable. In recognition of this engineering feat, the dam was designated a National Historic Civil Engineering Landmark in a ceremony in the park on April 20, 1971, when Samuel Baxter, president of the American Society of Civil Engineers, presented a plaque to Mayor D'Alesandro. Also in attendance was the president of the city council, William Donald Schaefer. In addition, the dam was designated a National Water Landmark by the American Water Works Association in 1973. Many other designated attractions outlived their usefulness and had to be replaced, but the Druid Hill dam continues to serve Baltimore into its second century of use.

In 1924, the lake was drained to update and reroute the pipes and alter the purification system. (This was done again in 1959 to improve the circulation and to

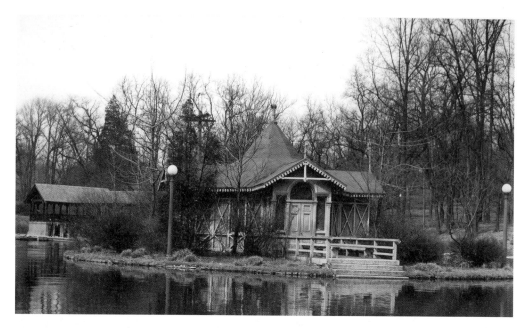

The boathouse, 1912.

build a new chlorinator station.) A fountain on the west side of the lake was built to replace a small nineteenth-century water spray. Today, Druid Lake continues to supply water to many of the southeastern neighborhoods of the city. At one time there was a thin path called Gravel Drive surrounding the lake, where ladies in their long skirts rode sidesaddle with their escorts to the bridal paths in Druid Hill Park. Most recently, the last segment of road around the lake was completed by the Department of Transportation. The 1½-mile path is well used by walkers, joggers and cyclists, and exercise stations were recently added.

High Service and Mount Royal Reservoirs

The creation of the High Service and Mount Royal Reservoirs in Druid Hill Park helped alleviate the pressure for drinking water in Baltimore. The Mount Royal Reservoir, located just east of Mount Royal Terrace, was created in 1862 and abandoned in 1910. Demolition of this reservoir was completed in March 1924 by moving fifty thousand cubic feet of earth in sixty days. At one time, the Olmsted brothers planned to convert the area into a giant swimming pool. It is the reservoir that gives the Reservoir Hill neighborhood its name, and Interstate 83 now occupies the land that held it. Construction of the High Service Reservoir began right after Druid Hill Lake was completed in 1871. It was the second major body of water created in the park. Due to citywide water shortages, it was not completed until 1874. It was located behind the Reptile House near Greenspring Avenue, where the ball fields are now.

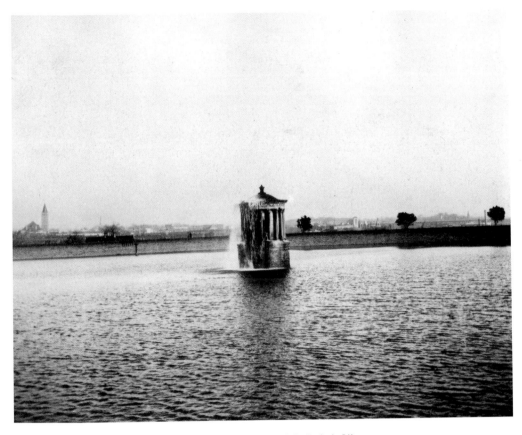

Druid Lake Reservoir, from *Artwork of Baltimore. Courtesy of the Peabody Library.*

The Reptile House

The building that until 2004 was known as the Reptile or Snake House started out life in 1914 as the pump house, regulating flow for the High Service Reservoir. The building closed in 1928, when the water from Lake Ashburton was used to serve the area instead. The building survived thwarted plans to tear it down and instead was converted into an elaborate aquarium. The Depression left a hole in the pocket of the city's finances, and in 1938 a smaller, less expensive aquarium was created using financial assistance from the Works Progress Administration. Fish, crabs and exotic tropicals were on display. Inside, murals by local artist Donald Coale were carried out under the guidance of a city naturalist and marble, terrazzo and ceramic tile floors decorated the interior. Upkeep became too expensive, and in 1948 the zoo converted it into the Reptile House. The Reptile House was a favorite venue of many who were looking for a short adventure. Since it was separate from the zoo, there were no lines or parking issues. It was an easy twenty-minute excursion for people with a little time, adults and children alike. At the time of its closing in the summer of 2004, the Reptile House was the best deal in town at one dollar a visit for a non-zoo member. For members, it was free. Kids loved to spy

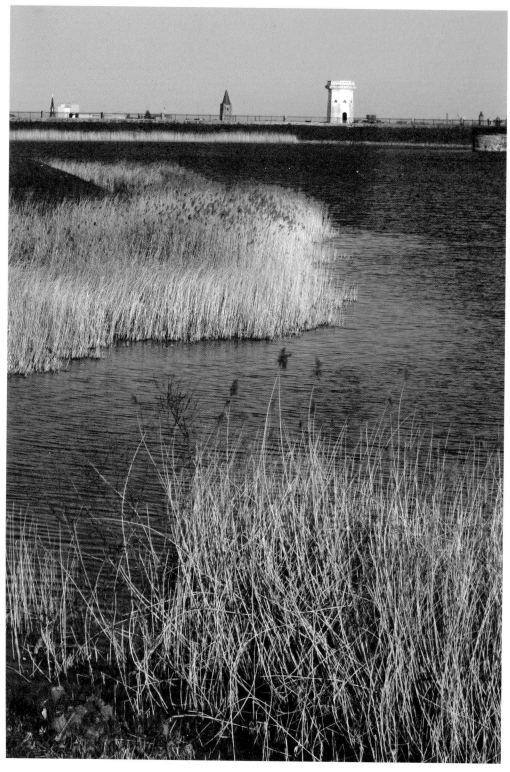

View of the lake and tower. *Courtesy of Donna Stupski, 2007.*

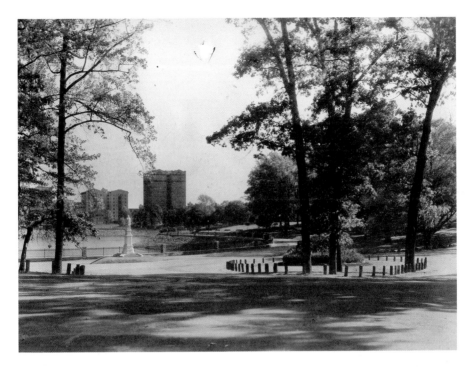

Druid Lake Reservoir.

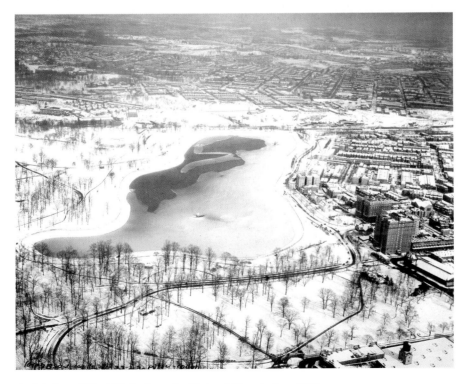

Aerial view of Druid Lake from the National Guard, circa 1920.

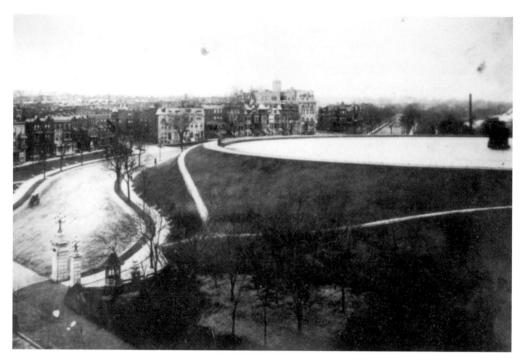

The Mount Royal Reservoir from North Avenue.

on the blue dart frogs, tomato frogs and the numerous lizards and turtles. The Reptile House was the home of the oldest resident of the zoo and, in fact, the oldest mud turtle in captivity. Sunni had lived at the zoo since 1953. She and the other residents of the Reptile House were sent to new homes when the building closed in July 2004.

Water

Druid Hill Park is located in the Jones Falls Watershed. The vast majority of Druid Hill's water drains toward the north and east and enters the Jones Falls. Since the Jones Falls is a highly urbanized watershed, Druid Hill serves an important function as the last source of water flowing into the stream from a forested and more natural area.

A well-drained, rocky underground allowed for fresh springs to bubble up through the earth, providing the residents of the ancient estate with spring-fresh water. By the nineteenth century, there were twelve documented springs in use, and three fountains near the mansion house. These springs were available to visitors and locals, human and horse alike. Children with wagons filled with jugs would bring back fresh water to their neighborhoods. The water was said always to be cool and fresh and probably tasted wonderful, especially compared to what was offered in the urban neighborhoods. A young entrepreneur could make a bundle from filling gallon jugs for people wanting some of the special water. According to the book *Druid Hill Park*

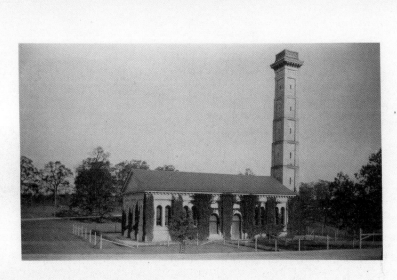

PUMP HOUSE, HIGH SERVICE RESERVOIR.

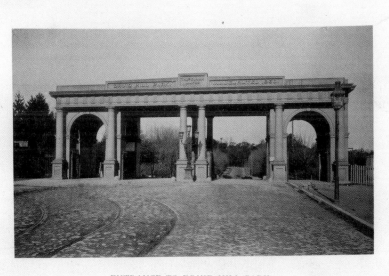

ENTRANCE TO DRUID HILL PARK.

Revisited, published by the Friends of Druid Hill Park, one boy earned the enormous sum of $300 one summer carting the filled jugs to patrons. Many regular drinkers believed that the waters were medicinal and offered health benefits. Some even considered the water holy, and there were reports of baptisms taking place in Druid Hill Park.

Three Sisters

The Three Sisters Ponds, in the northern part of the park off Greenspring Avenue, were originally created as five pools. The ponds served as a Fish Hatchery and one later became home to the zoo's sea lion exhibit, using water piped in from the now defunct High Service Reservoir. At the time, the ponds' circulation system drained into streams that flowed into Woodberry. Water issues in the 1960s caused the ponds to close, and they were abandoned for forty years. For many years the Three Sisters were hidden beneath brush and overgrowth, invisible to the casual eye. Renovation of these ponds and the surrounding area was suggested in the 1995 Master Plan for the park. A planned restoration by the Department of Recreation and Parks will restore the area to its former glory.

Within several years of the purchase of the park, the springs were adorned with statues and structures, many of which were designed by George Frederick in gothic and classical styles. Donations came from various affluent citizens to decorate the mouth of

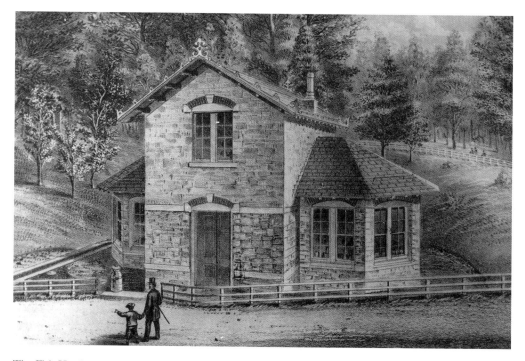

The Fish Hatchery.

each spring. There were benches and metal cups for visitors at each site. Filled horse troughs were available at three springs located at Mountain Pass, High Service and Garrett Bridge. Each spring was given a name:

HIGH SERVICE SPRING

ROGERS SPRING was the spring used by the Rogers family for generations. It was located near the Rogers/Buchanan burial site, although nothing of this once-popular spring remains.

SILVER SPRING (1862) was one of the first springs to be constructed in the park and one of the last two to be closed. George A. Frederick designed the Gothic-style 1862 structure, funded by Gerard T. Hopkins. It was a favorite among picnickers and some visitors even believed it had the best water. Four metal dipping cups were attached for anyone needing a drink. The Health Department closed it down in 1932 and nothing of the beautiful structure remains today.

EDMUNDS WELL (1865) is by the old boat lake and is the oldest decorated spring. It was funded by John A. Needles and dedicated to his son Edmund. It was from this well, when the city wanted to condemn the water as impure, that Superintendent Cassell took samples to compare with the city water. When authorities confirmed that the city water was much purer, Cassell admitted to having switched the samples; the pure water was from Edmunds Well.

CRISES FOUNTAIN (1870). Funded by John L. Crise, this is one of the loveliest and one of the last springs to be closed. A statue of a reclining woman tops the fountain and

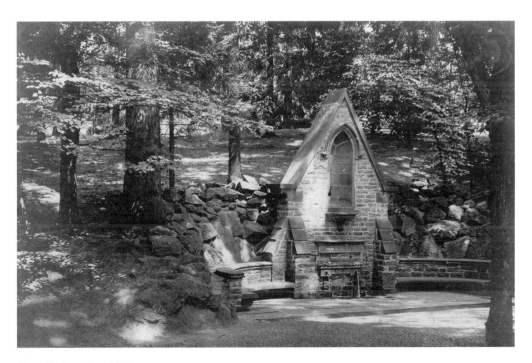

Silver Spring, circa 1870.

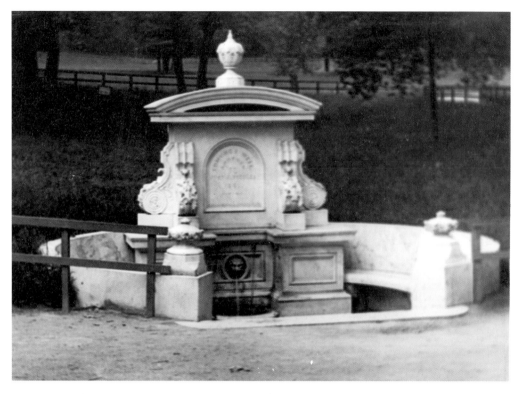

Edmunds Well, circa 1870.

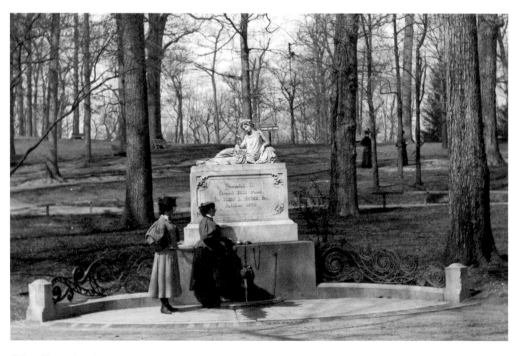

Crises Fountain, circa 1880.

water flowed from three bronze lions' heads. It had the strongest flow and coolest water, due to the ice packed around the coils. It is located inside the zoo near what had been the duck pond.

MORRIS FOUNTAIN (1885). A remnant of this fountain can be found near the pastoral Philosopher's Walk inside the zoo. It may have been the very last to be closed.

MOUNTAIN PASS SPRING was also called Hog Fountain.

RIPPLE SPRING (near the swimming pool)

COLONIAL SPRING was near Garrett Bridge and was made of brick. It, like Rogers Spring, was used by generations of the Rogers/Buchanan family.

GARRETT BRIDGE SPRING was probably located near Garrett Bridge as well.

BULL FOUNTAIN was donated by Mrs. W.C. Conince in the name of her grandson, William Bull.

SCREEN WELL SPRING

COTTAGE SPRING

Sadly, nearby development was the death of the pristine waters that once ran through these springs. After World War II, construction in the Belvedere and Park Heights areas just north of the park caused contamination of the water and the springs, and one by one they were shut down. Several of the springs survived into the 1940s, but the Health Department found *bacillus coli* and other contaminants and eventually all the springs

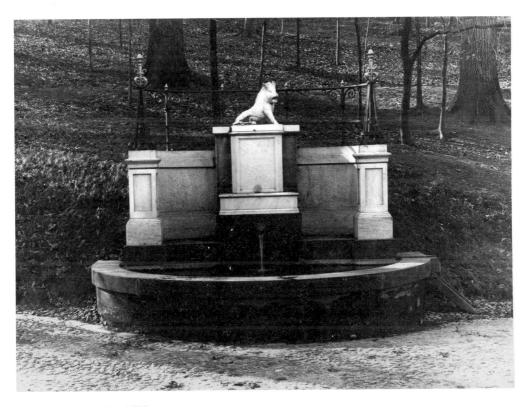

Morris Fountain, circa 1890.

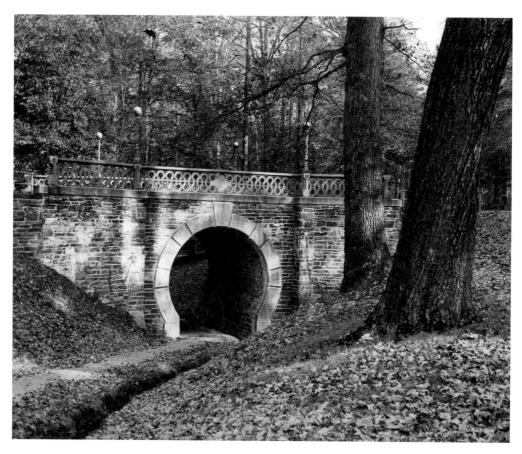

Garrett Bridge.

were closed. This was heartbreaking for many in the surrounding neighborhoods who had counted on this fresh water and enjoyed the cool refreshment through the warm summer months. Some were skeptical and offered that the city's water was worse and contained more bacteria and contaminants. Some tests reportedly proved as much, but the springs never reopened and many have been lost forever.

The Grove of Remembrance

On October 8, 1919, trees were planted in Druid Hill Park, just north of the zoo, in memory of the fallen soldiers of World War I. It is said to be the oldest living memorial in the country. A plaque memorializing the planting stands in front of the grove. This was the year that the War Mothers of America gathered in Baltimore for the organization's second national convention. This group, led by Mrs. Robert Carleton of Toledo, Ohio, was the first of its kind to be inspired by World War I. Mrs. Carleton suggested planting a grove of trees in honor of the fallen sons. The state donated a swamp white oak for each

of the forty-eight states, one for Baltimore, one for the Allies and one for our wartime president, Woodrow Wilson. They were planted by Gold Star mothers from Texas, the Gold Star State. The French ambassador, Jules Jusserand, Maryland Governor Emerson Harrington and Mayor William Broening were among the dignitaries present. The parade was composed of one thousand schoolchildren carrying American flags along with Civil War veterans, including wounded men from the army hospital at Fort McHenry. For years, on Mother's Day, people would come to the grove to remember. In 1927, Colonel Israel Rosenfeld donated funds for the construction of the pavilion in memory of his son, Merrill Rosenfeld, first lieutenant, 115th Infantry, who was killed in action in 1918. He had been awarded the Distinguished Service Cross for Extraordinary Heroism. On May 12, 1985, the grove was rededicated, along with a new weeping beech tree, to honor those who served in Vietnam. This event came after five years of fundraising by a small group of determined park lovers, the Friends of Druid Hill Park, to replant and prune trees, replace bronze markers and restore the pavilion.

Baltimore Tower

Another George Frederick design, the Baltimore Tower (also called the White or Moorish Tower), was constructed out of white marble circa 1870. It is an example of an exotic style of architecture having Islamic influences. Its thirty-four-foot-high walls are eighteen inches thick and it stands at one of the highest points in the city. Over the entrance is a water pitcher relief. The landmark was a destination for cyclists, horseback riders and those out for a Sunday carriage ride around the lake. People could climb the stairs to the top to see a spectacular view of the city. For years the tower sat neglected, its outer structures decaying, its flagpole rotting. But attempts to take action and tear it down were thwarted not only by those interested in preserving it, but also by the fact that its walls were prohibitively thick for demolishing. It was its own integrity that kept it from being lost to posterity. It closed to the public in the 1930s. The Department of Public Works restored the tower in the 1990s and removed the spiral staircase.

The Band Shell

Another George Frederick building was the Bandstand, or Music Pavilion, located at the end of the Grand Promenade or yellow brick road behind the conservatory. The turnip-shaped dome defines its Moorish character. It was a popular destination for many park visitors and had been a stage for music and the venue for the park band. Visitors could take the trolley, walk or ride carriages to the Promenade and stroll up to the Bandstand to listen to the park band play. The yellow brick road behind the conservatory still exists, but the Bandstand deteriorated and was torn down in 1961.

Druid Hill Park's Moorish Tower, circa 1915. *Photo by the Baltimore Camera Club.*

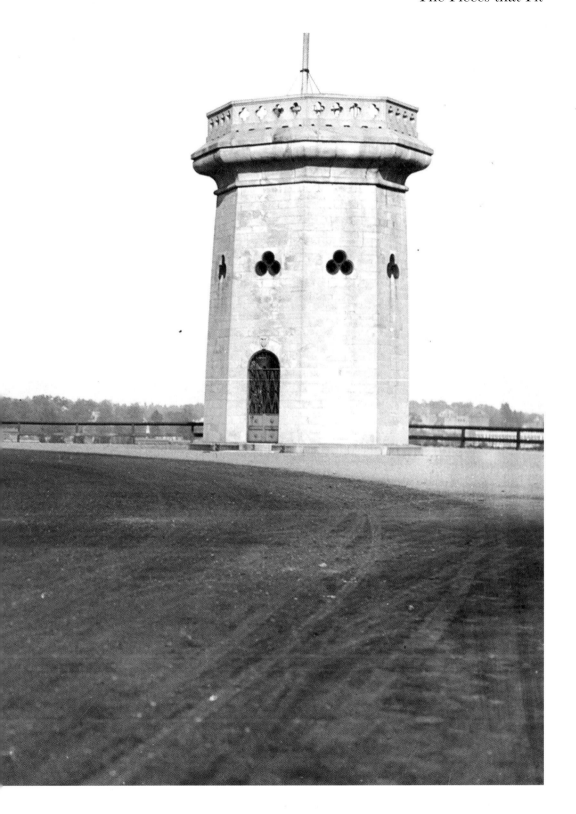

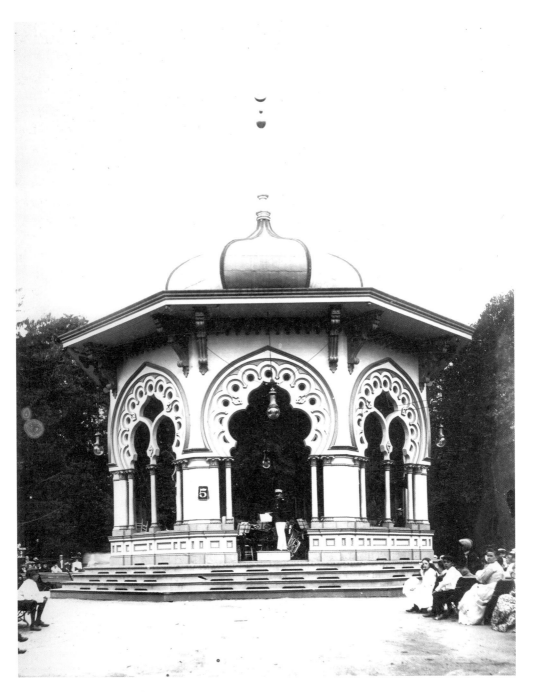

Druid Hill Park Bandstand.

The Sundial

Druid Hill Park's famous and most unusual sundial just might be the strangest looking thing that ever had a purpose, although, by looking at it, one can hardly guess what that purpose might be. It has fourteen "gnomons" (the triangular pieces of metal sticking up to create the function of the sundial) standing erect from the clock face surfaces that serve to tell the time. It looks like a confusing, perhaps dangerous element of war, or something that might react negatively to the touch. In fact, this timeless timepiece was created in 1890 by Peter Hamilton, a stonemason and president of the Guilford and Waltersville Granite Company. Built under the direction of professors of mathematics from Johns Hopkins, this amazing timepiece gives the time for Cape Cod, Rio de Janeiro, San Francisco, Pitcairn Island, Sitka, Honolulu, Jeddo (Tokyo), Calcutta, Cape Town, Jerusalem, Fernando Po and London. But don't use it to set your watch. The sundial does not follow standard time (established in 1884) and can be grossly inaccurate, especially during daylight savings. It now resides in the conservatory gardens.

The Statues

While there are many statues throughout the park, not all are known by the casual visitor. Some of the statues have been moved over the years. A keen eye may recognize a long-standing statue in a surprisingly new place. Some, such as the Four Seasons and statues representing Europe, Asia, Africa and North America, have been lost.

The following statues are listed in alphabetical order and include those listed in the publication of Friends of Druid Hill Park:

Boy and Goose

This statue is a replica of a work by the second-century Greek sculptor Boethus. Much of his work included images of children and this is one of his most famous pieces. The original resides in the Louvre in Paris. The replica was presented to the park in 1966 as a gift from prominent Baltimore resident George Bartlett. The statue was originally located outside the main entrance of the zoo in Council Grove and now resides inside the zoo gates.

Cast-iron Lions

These lions originally came to Baltimore as gifts to Thomas Winans in the mid-nineteenth century. They were shipped from Russia during Winans's tenure as railroad advisor to Czar Nicholas I and builder of the first railroad. The formidable creatures stood at Crimea, Winans's palatial home estate. The lions were given as a gift to the zoo in July 1960. They now stand inside the entrance to the zoo.

The remarkable sundial, 1905.

Cherubs

Twenty cherub relief panels were created by British artist John Monroe after his completion of the Albert Memorial in London. Monroe was paid $1,320 per panel. They were on the wall of the post office at Calvert and Fayette. These reliefs were separated in 1930 when the post office was demolished. Baltimorean William H. Parker purchased two. He had worked on the stones and felt, most likely, that he was saving them from loss. One panel is privately held and another was donated to the Park Commissioners. The others have been lost to time. The public one (four feet high, eight feet long and six feet thick) is now located beside the Recreation and Parks building at 2600 Madison, just west of the arches. It was installed in 1933, according to *Druid Hill Park Revisited*, in honor of the end of Prohibition. The installation seems to have coincided with the date when beer was allowed back into Baltimore.

Columbus Statue

This statue, perhaps one of the most prominent in the park, was a gift from the Italian community of Baltimore in 1892, on the four hundredth anniversary of Columbus's arrival on American shores. This life-size statue with pedestal reaches eighteen feet. The dedication reads, "Christoforo Colombo, The Italians of Baltimore, 1892." The original was created by nineteenth-century Genovese artist Achille Canessa and resides in Genoa. For half a century, Columbus Day in Baltimore included a gathering at the site of the statue. It is said that at times over 100,000 people would come to the park to celebrate, including several Italian dignitaries. In 1984, the statue was restored and now stands on the northwest side of the reservoir.

The Gorilla

This small statue was given to the zoo in 1948. It was sculpted by Baltimore artist Valerie Harisse Walters (1920–1979), who was intrigued by a gorilla named John Daniel II. The animal was on a tour of America with its British owner. Ms. Walters sculpted the animal from life in 1924. It was given to the zoo, where it remains today.

Memorial to the Marylanders Killed in the War with Mexico, 1846–1878

This statue was erected by the Maryland Association of Veterans of the Mexican War in 1903 in honor of General Watson, a native Baltimorean. Sculpted by Edward Berge, the monument stands in the park near North Avenue and Mount Royal Terrace.

Union Soldiers and Sailors Monument

Erected in 1909 and placed at the foot of the earthen dam, this monument is now at the northwest corner of Twenty-ninth and North Charles Street in Wyman Park Dell.

Lakeside Drive and Columbus Statue, Baltimore, Md.

The Columbus Statue.

Wagner Bust

This statue was presented in 1901 to the city of Baltimore by the United Singers of Baltimore. The gift came a year after this group won first prize at the Nineteenth Triennial National Saengerfest competition in Brooklyn, New York. The sculptor was R.P. Golde of New York City. It was dedicated in Druid Hill Park on October 6, 1901, before a large crowd and remains on the southeast corner of the mansion house lawn.

Wallace the Scot

On St. Andrew's Day, November 30, 1893, this statue of William Wallace was presented to Baltimore. The statue was a gift from William Wallace Spence, a Scottish immigrant and wealthy Baltimore businessman who three years later donated the statue of the Divine Healer to Johns Hopkins. The original statue, which William Wallace Spence saw in Scotland, was created by Scottish artist David Watson Stevenson (1842–1904) and resides in Stirling, Scotland. The Druid Hill replica's inscription reads, "Wallace, Patriot and Martyr for Scottish Liberty, 1305." The dedication ceremony included bagpipes, speeches and general fanfare. From pedestal to sword, the statue stands seventeen feet tall and still brings those who pay homage, including the Scottish Society, on St. Andrew's Day. The statue stands on the west side of the reservoir.

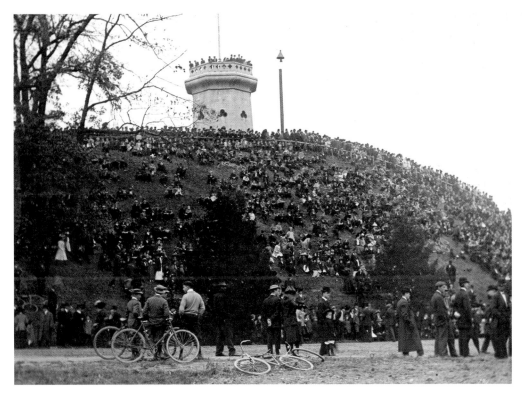

Dedication of the Union Soldiers and Sailors Monument, 1910.

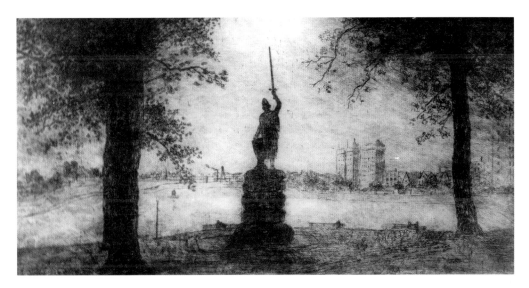

The William Wallace Statue.

Union Soldiers and Sailors Monument.

George Washington

Noah Walker, a clothier and owner of Baltimore's premier emporium for clothing and dry goods, commissioned a statue of George Washington in 1858 for a new building he was erecting downtown called the Washington Building. A young American artist living in Rome, Edward Sheffield Bartholomew (1822–1858), was paid $6,000. The statue stood on the front of the second floor of the building, lit at night by a circle of gaslights. After Mr. Walker's death, in the late nineteenth century the family donated it to the city. The statue, having been located on the front of the building, had no back. A niche was made by George Man and Son. Enoch Pratt, the philanthropist, donated the pedestal. The statue now stands inside the Madison Avenue entrance on Swann Drive.

Seated Woman

Located on Mount Royal Terrace just north of North Avenue, there were three similar statues on the Old St. Paul Street Bridge. Mayor Schaffer gave one to Baltimore County, Ireland, and the other two can be found on the grounds of Cylburn Arboretum. On a plaque located on the base is written, "St. Paul St. Bridge, J.A. Tegmeyer, City Commissioner. C.A. Latrobe, Engineer. 1880."

Beauty at Play

The park was a popular venue during the latter part of the nineteenth century. In his invaluable book *History of Baltimore City and County*, Thomas Sharf writes of Druid Hill Park in his section "Monuments, Parks, and Squares." Written in 1880, this book gives much information on Baltimore and its noteworthy citizens up until that era. Sharf commented on Druid Hill Park:

> *Its beauties are probably superior to any other public park in the country, and have been heightened and set off by judicious taste which has known how to avoid meretricious show, and to recognize the fact that in this as in other cases nature is best adorned when least adorned…the park has been made attractive outside of its beautiful scenery, but it has been to small extent ornamented.*

The Olmsted Brothers

No prominent park of the nineteenth century could call itself into distinction without the hand of Olmsted. Frederick Law Olmsted may be America's most famous landscape architect. In addition to being the cofounder of the publication *The Nation*, Olmsted was also the visionary behind Central Park. His designs inspired parks around the country. He had an impressive career as a journalist and during his travels wrote numerous articles condemning the odious practice of slavery. Olmsted was influenced by Andrew Jackson Downing, who had originally proposed the idea of creating Central Park. Druid Hill Park, as we have seen, shares a kindred spirit with New York's most famous park. Druid Hill Park was crafted in the same design convention of the time—the English country landscape.

In 1883, Frederick Law Olmsted established his business in Brookline, Massachusetts. It was the country's first real landscape design firm. In 1895, when he retired, his sons

(actually, his adopted son/nephew, John, and his son, Frederick Law Olmsted Jr.) took over the firm. It was renamed the Olmsted Brothers, Landscape Architects (OBLA). In addition to their distinction in the profession of landscape architecture, the Olmsted Brothers were also leaders in the profession of city planning as it developed around the turn of the twentieth century. Recognizing OBLA's excellence in planning, the Municipal Arts Society hired the firm to develop a comprehensive plan for Baltimore. In 1904, the company published *Report Upon the Development of Public Grounds for Greater Baltimore*, which developed the concept for a park system for the Baltimore region and formed the basis for the ongoing development of Baltimore's park system.

The 1904 plan was a conceptual one that proposed linking Baltimore's large parks, such as Druid Hill, through a system of boulevards and stream valley parks. While the plan did not directly address Druid Hill, the Olmsted Brothers were hired as consultants for various projects throughout Baltimore's existing park system, including Druid Hill Park. The firm worked collaboratively with the in-house designers and engineers of the Baltimore Park Commission.

The firm envisioned expansive Druid Hill Park as the anchor of the city's park system. Over the next few years, as they penned designs and drew up plans, work was begun on several of their projects. The fire of 1904 may have diverted attention and funds from Druid Hill Park toward urban reconstruction projects; however, there are many documents from 1904 to 1916 showing designs, surveys and plans by the firm. They provided designs for the Grande Promenade or Mall and the paving pattern still exists. Their work focused primarily on the entryways at Fulton Avenue, Mount Royal and Pimlico Circle; planting plans; modifications to park edges, especially the southern edge; and some internal circulation and grading, as well as the stables area and Seven Oaks. Much of this work was done long distance from their offices in Brookline, Massachusetts, and things moved slowly.

In 1907 they made plans for topographical and grading changes, and the following year they addressed the monument to Union soldiers and sailors. There were discussions and disagreements with the Municipal Art Council, which wanted a sculpture garden built. The Olmsteds were concerned about the negative effect on the bucolic landscape. In 1911, more plans were requested and several designs were submitted for widening paths and gardens. One such design pays tribute to an unfortunate side of the park's history. A 1912 plan shows designs for separate playgrounds for black and white children.

Records are incomplete, but the Olmsted Brothers worked on plans for Druid Hill sporadically over the next several decades, including a new design for the iron fence surrounding Druid Lake. Plans were requested, carefully considered and certainly, whether used or not, influenced the overall design decisions that were ultimately implemented. Needless to say, the Olmsted Brothers' influence on the development of Druid Hill Park is clear, as their vision helped to define and retain the park's image and its wealth of natural space.

A member of the Baltimore Riding Club. *Photo by the Baltimore Camera Club, circa 1890.*

Park workers tending to the leaves in autumn, circa 1890.

St. Paul's Cemetery

The land upon which St. Paul's Cemetery sits was purchased in October 1854 for the sum of $3,000 from "Francis Hillberg and his wife." The land was not part of the Rogers/Buchanan family estate and records indicate that Nicholas Rogers IV allocated land to be given to a church.

The church was then known as the Second Evangelical Lutheran Congregation of Baltimore. The members were almost exclusively German and most of the old records were written in German. Bodies were transported from the original cemetery on Madison Avenue. A dedication ceremony was held on December 10, 1854. By 1868, the city took half of the land, reducing the original 4½ acres to 2¼. The church divided and the cemetery was sold to three newly formed congregations (which had constituted the original church) and a new deed was written. The new set of rules adapted by the congregations required that "only members of our congregations or members of congregations of like faith, may possess lots and have burial rights, whereas" members "carry all the costs of improvements to the cemetery"; "no lot owner has the right to bury blatant blasphemes, those excommunicated, [or] those living sinfully"; "no outside minister or any other person may give a speech at the cemetery without special permission from the pastor"; and "no group may make an appearance, with or without music, at the cemetery." The land was known as God's Acres. Many members of the German community, descendants of those buried there, are still connected to the church of their ancestors. Today, the Martini Lutheran Church located on Henrietta and Hanover Streets in South Baltimore owns and maintains the cemetery. The most recent burial was in October 2005.

The Conservatory

The conservatory was and is a jewel in Druid Hill Park. Its beautiful curved lines, attenuated roof, glass and steel at its most elegant make it a striking sight. It was originally called the Palm House and was designed by George Frederick.

At a time when Darwin's influence went beyond concerns about our origins, the desire to collect specimens led to the building of greenhouses around the world. The Crystal Palace Era was ushered in by a magnificent building designed to house Prince Albert's grandiose international extravaganza. The structure was christened the Crystal Palace by editor Douglas Jerrold and held the Great Exhibition of the Works of Industry of all Nations from May through October 1851 in London's Hyde Park. The amazing structure was designed by Joseph Paxton (1803–1865), head gardener at Chatsworth in Derbyshire. His creation is considered to be the forerunner of the modern greenhouse.

The London structure was built as a temporary house for the exhibition, but it influenced cities all over the world to build their own conservatories (botanical gardens or, as the French called them, "orangeries"). Although forms of indoor gardening and

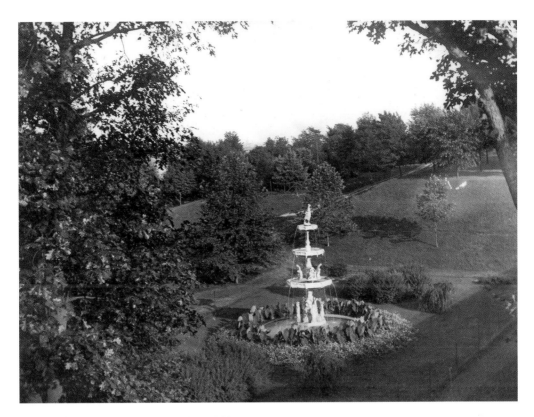

A view of the lawns and fountain, circa 1900.

botanical gardens had been employed since the times of the Romans, it was this era that sparked the creation of the large glass and steel structures, like the Howard Peter Rawlings Conservatory in Druid Hill Park.

A plot was selected and retained for the conservatory in 1873, at the same time official zoo plans were being made. The two venues were, in fact, sisters in many ways. Besides being planned at the same time, the two facilities both provided visitors with rare glimpses at exotic plants and animals. In the conservatory, strollers could examine the palms and other flora from faraway lands. At the zoo, creatures from far and wide were available for viewing, free of charge.

The Palm House (the dominant structure) and the Orchid Room were completed in 1888. The Palm House is constructed of glass panes divided by wooden members that form a high, vaulted structure capable of accommodating the tall palm trees. It was one of four park-hosted conservatories in Baltimore. The greenhouses in Patterson Park, Lake Clifton and Carroll Park no longer exist.

In 1926, nationally known New York horticulturalist Alpheus De La Mare was enlisted as consultant for the new rose gardens.

Tulips

At one time, Druid Hill Park contained a "tulip index" planted in front of the Park Administration Building at 2600 Madison Avenue. Parks Board secretary J.V. Kelly, who served for many years, decided catalogues did not offer sufficient images of the color variations, so he decided to plant his own catalogue. He created a bed containing 6 species of tulip and 118 different varieties. The different colors, shades and combinations of colors totaled 1,371 and the beds where laid out in eleven sections designated by signs lettered from A to H and X, Y and Z. The bulbs were set in rows, eight inches apart, five to a row. The bed illustrated most of the possible colors and forms that gardeners could expect from tulips. Horticulturalists from far away came to Baltimore for no other reason than to look at the index. Since tulips run fairly true to form, anyone could choose a tulip variety from the living index and order the flower from a dealer, expecting to receive the same as chosen. Kelly used the tulip index to decide what to plant in the parks. Beginning in 1939, however, no replacement tulips were available from Holland, since the country was then under Nazi control. A 1942 article discussed the problem.

By the turn of the century, twenty tennis courts were built surrounding the conservatory. It was on these courts that a most significant civil rights protest would be staged.

The American Parks Movement Leads to the American Playground Movement

According to Dr. Joe L. Frost, America can trace its roots of planned playgrounds back to an outdoor version of the German "gymnasia," although in 1821 this was little more than indoor fitness equipment brought outside. It was limited and available only to older boys, but it did spark the idea of outdoor play and facilities to support it. The movement to attend to the outdoor needs of children followed on the heels of the American Parks Movement. By 1886, Boston had created a "sandgarten" play lot. Bostonian Joseph Lee, "father of the American playground," gave up a career in law to study and act in the support of play for children. The early 1900s introduced the American Playground Movement. This movement focused on the idea that physical activity and play are important for all and provided a remedy against the dangers of urban play and the inadequate spaces for children to play safely. Public school and community playgrounds began to appear and there developed an industry in the manufacturing of jungle gyms (climbing structures), swings, seesaws, slides and more.

Unlike the Victorian pastoral views, strolling paths and picnic areas that had been the aim of parks, the new century brought sports and playgrounds. Baltimore's Robert Garrett helped to found the Playground Association of America (later the National Recreation Association) in 1906. This group worked on a national level, attempting

to bring the playground movement into organized action. Locally, Garrett was taking action as well. For several years Druid Hill Park had fields on which children could play ball, and by the turn of the century, Druid Hill Park had acquired tennis courts, running tracks, playing fields and athletic equipment.

The Work of Robert Garrett

Robert Garrett was born in 1875 with the proverbial silver spoon in his mouth. By his time, three generations of Garretts had made their mark on Baltimore. Garrett's grandfather, also Robert Garrett, had built a mercantile business, promoted the Baltimore & Ohio Railroad and built two hotels, as well as a steamship aimed at connecting Baltimore to San Francisco. His son, John Work Garrett, was born in 1820, studied at Princeton and, unlike many wealthy Marylanders, was a fierce Union supporter during the Civil War. John Work Garrett financed and built Garrett Bridge, which lies in Druid Hill Park within zoo boundaries.

Olympic Champion

While at Princeton, Robert Garrett participated in athletics and was excellent at track and field. In 1896, the year before he graduated, Robert Garrett paid for himself and three other athletes to travel to Athens for the first modern revival of the ancient Olympic games, where Garrett won a gold medal for the discus and two silvers in long and high jumps.

Upon returning to Baltimore, with wealth and health on his side, he became a patron to many of his passions. In 1900, he founded the Public Athletic League, or PAL (later the Playground Athletic League). Gold medal Olympic champion Robert Garrett was also becoming a champion of children in Baltimore. He organized and, to a large degree, financed outdoor gymnasia for the benefit of local boys. Set up in lots and parks around the city, there were four original playgrounds. Each space was provided with an instructor so the benefit of physical education could be maximized as well as supervised.

The Merger of CPA and PAL

By 1897, the playground movement was happening nationally and cities were taking into account the importance of a healthy physical life for children. Baltimore was on the cutting edge. The Children's Aid Society, founded in New York City by Charles Loring Brace in 1853, found a home in Baltimore by 1860. In 1897, the first playground opened in Druid Hill Park. This playground was the fruit of the labor of two women, Eliza Ridgely and Eleanor Freeland, who fronted the Children's

Playground Association. The women had been inspired by Joseph Lee's work in Boston. With funding from the Good Government Club, they applied for space in Druid Hill Park expressly for a playground where children could take some exercise. Druid Hill became home to Baltimore's first designated playground.

In 1900, the Children's Playground Association's report to the Parks Board showed that they were servicing four to six hundred children, mostly younger boys and girls, daily in the playgrounds in three parks: Patterson, Riverside and Druid Hill. The playgrounds were only open six days a week in the summer and all play was supervised. Favorite games were said to have included marbles, tops, jacks, beanbags and "Go Round the Mountain Two by Two." By 1902, CPA was operating playgrounds in spaces throughout Baltimore.

By 1906 their scope had expanded to include a circulating library to promote reading. They also offered cooking classes and gardening. According to Barry Kessler's book, *A Playlife of a City*, by 1906 the CPA had an attendance of 300,000. They were constantly looking for more space.

In 1922, the Children's Playground Association and Garrett's Public Athletic League merged and began operating under the name Playground Athletic League, serving boys and girls of all ages. Robert Garrett would go on to serve as president for many years to come. The Playground Athletic League was, in fact, the forerunner of the Bureau of Recreation, which merged with the Department of Parks, becoming the Department of Recreation and Parks, as it is today. PAL was part of the Parks Board budget until the 1940s, when it was absorbed into the government department. In 1936, the program ran year-round and included arts, drama, dance and nature study. On January 1, 1940, Baltimore's private recreation agencies became part of the Department of Recreation. Druid Hill Park had, by then, changed in many ways.

Changes in Druid Hill Park

Automobiles

Early in the century, the first "horseless carriages" appeared in Druid Hill and along with them came the Automobile Act of 1902, which maintained the Parks Board's authority to regulate traffic within one mile of parks and to impose fines for violations. According to Eric Holcomb's book *The City as Suburb: A History of Northeast Baltimore since 1660*, Baltimore presented its first automobile show in 1906. Seven hundred owners were invited. By 1912, 80 percent of the arrests made in parks (out of 112) were for reckless driving and noise. Parks Board minutes in 1921 indicate Druid Hill Park's roads were being widened to accommodate cars, Pimlico Circle was made smaller and lighting was increased to reduce automobile crashes into the lake fence. In the Park Commission's minutes dated September 22, 1925, it is noted that nearly twenty thousand cars passed one point in Druid Hill Park in one eleven-hour period.

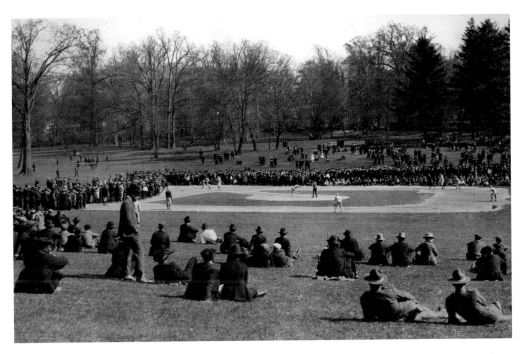

This 1931 photo shows a baseball game at Druid Hill Park. The spectators are mostly, although not all, African American.

Children at fountain, circa 1920s.

Interestingly, a few years earlier in 1895, *Evening Sun* bicycle editor J. Edwin Murphy was asked to "persuade the Baltimore Parks Board to rescind an order barring bicycles from Druid Hill Park."

It was difficult to govern the new automobile craze. The new Druid Park Lake Drive, built in the late 1940s, created a barrier between the park and the neighborhoods south and southwest. The quiet lake was lost forever when the roadway was enlarged. The grand homes along the park still had the lovely view of the rolling hills and shining lake, but access became much more difficult.

I-83

In the 1960s another road greatly impacting Druid Hill was Interstate 83, which runs from Harrisburg, Pennsylvania, to Fayette Street in downtown Baltimore. As it runs through the city, it more or less follows the route of the Jones Falls and is called the Jones Falls Expressway (JFX). It was the first interstate to be built in Baltimore. By the mid-sixties, most of the freeway was complete within the city limits, although some parts toward downtown were not finished until 1983. During construction, the slopes below Druid Hill Lake were regraded and resulted in the loss of more than an acre of the park. Additional land was lost east of Mount Royal and north of the Cedar Avenue Bridge. I-83 now forms the eastern boundary of Druid Hill Park and has changed the quiet

Automobile driving along Crow's Nest, circa 1910.

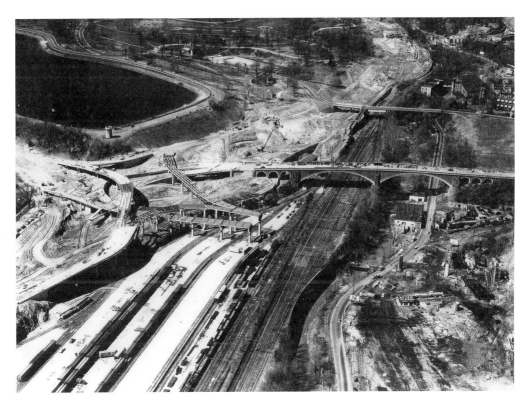

Construction of the Jones Falls Expressway.

nature of the surrounding area. Although the park and zoo were made more accessible by visitors traveling by car, the park also became more isolated and less easily accessible to the surrounding neighborhoods.

Jewish Neighbors

From the 1870s through the 1930s, Eutaw Place was a center for wealthy German Jewish families. The 1880s brought Eastern European Jewish immigrants to the area, and a large number of the relatively Americanized German Jews migrated out of East Baltimore and into the lovely upscale Eutaw Place. Large, elegant mansions complete with finery, literary clubs and elegant synagogues were plentiful among these successful Baltimoreans. Before World War I, while much of the area around Druid Hill Park became an exclusive upper-class German Jewish enclave, neighborhoods to the east of the Jones Falls had anti-Semitic clauses in their homeowners' contracts. By the 1890s, families were moving to streets adjoining Eutaw Place such as Brooks Lane, Callow Avenue, Whitelock Street, Brookfield and Linden Avenue to create a neighborhood that became loosely known as Lake Drive. There were five notable apartment houses in the Lake Drive area: the Emersonian, Temple Gardens, the Esplanade, the Marlborough

Mount Royal Avenue, circa 1920.

Eutaw Place.

and the Riviera. Between 1893 and 1903, five synagogues were built in the area. The Orthodox Shaarei Tfiloh Synagogue that was founded on the corner of Auchentoroly and Liberty Heights in the early 1920s is still an active synagogue. Druid Hill Park was a main venue for the residents of the neighborhood.

The Jewish neighborhood extended over to Auchentoroly Terrace, which sits on the southwest side of the park. The area had been owned by George Buchanan and was sold to John Morris Orem by Lloyd Nicholas Rogers in 1856, before he sold Druid Hill to Baltimore City. Mr. Orem, a Baltimore dry goods magnate, built a large summer home on the land and named it Auchentoroly in honor of the Buchanan estate. In 1876, Orem built two other mansions on Auchentoroly Terrace and gave one each to his son and son-in-law. William Morris Orem's old mansion still stands at 3436 Auchentoroly Terrace and once housed the Park School.

Reservoir Hill, Hampden and the surrounding area have become more economically, racially and ethnically integrated than ever before, with African and Euro-American residents, as well as many Jewish neighbors. Many of the structures, houses and apartment buildings are original. The buildings include brownstones, brick row houses, Victorian mansions and classic turn-of-the-century apartment houses that overlook the park and reservoir. Part of Reservoir Hill has been classified as a historic district by the National Register of Historic Places.

Racial Turmoil and Civil Rights

The Two Faces of Baltimore

During the eras of slavery and later civil rights, Maryland was a dichotomy. At one time, prior to the Civil War, the state had the largest free black population in the country. At the same time, it played the role of a Southern state, possessing a large slave base. Free blacks could be found in many professions in Baltimore, including doctors and merchants. However, these professionals often lived in the mews rather than in the grand mansions that lined the high streets. In the 1830s, black-dominated fields still found that white bullying tactics were wrestling the work away.

Druid Hill Park and Baltimore, as a whole, have an incredibly mixed history of race relations. Documents and illustrations from the 1850s show families of different colors enjoying recreation and outdoor time in the parks without strife. In fact, Rule #1 of the Public Parks and Regulations established the parks as open to "all persons upon absolutely equal terms." The Enoch Pratt Free Library had a mandate on the same order as Rule #1. But Rule #1 was policy, not law, and as early as 1865 there were attempts at restrictions. Frederick Douglass, the brilliant speaker and great leader against slavery, was denied permission to lecture at the park. The Park Commission's decision to prevent this event from being held at Druid Hill Park marked the trend toward segregation that would take hold for the better part of a century.

Although there were Radical Republicans fighting for black rights throughout the South, there were also many who fought to retract promises that had been made during the post–Civil War Reconstruction. Redeemers (a Southern government movement aimed at overthrowing Radical Republicans and others who supported black rights) and former Confederates were able to turn back the rights and create what we know as Jim Crow laws. Jim Crow was a character in the minstrel show song "Jump Jim Crow" from 1828, sung by an English performer called Daddy Rice, who was said to be the first to use blackface.

In 1896 came the Supreme Court's decision in *Plessy v. Ferguson* that made legal the infamous motto "separate but equal." In 1904, Maryland passed its own Jim Crow laws and soon businesses and recreation venues were practicing voluntary segregation. This brought authorized divisions in the parks, although no actual legislation was passed for the segregation of parks. This action was allowed at the discretion of the board and authorities.

Druid Hill Separates Itself

During this heightened aggression against integration, Druid Hill became the sole park citywide where African Americans felt welcome in a recreation complex. In 1919, "Negro" tennis courts were built. These courts were home to legions of local tennis greats. Top men's singles players included Warren Weaver, John Woods, Irvington Williams and Douglas "Jacko" Henderson. A few outstanding women's players were Evelyn Scott, Nellie Brisco and Evelyn Freeman, who was the women's singles champion of 1949 and 1950 and was rated by the *Baltimore Afro-American Newspaper* as one of the top ten women's players in the country. In 1921, a pool for "Negro" patrons was built using filtered water. Wooden bathhouses were constructed along the side of the pool. The pool, grove of trees and tennis courts composed the "Negro" area in the park.

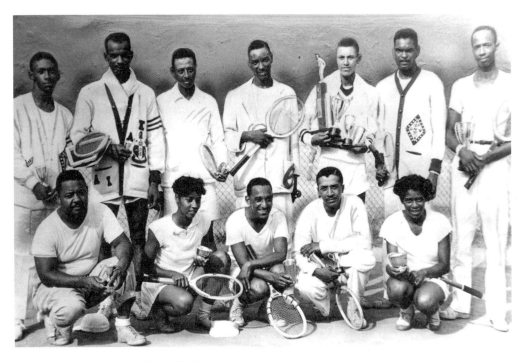

Members of the Baltimore Tennis Club.

From this point on and for over four decades, Druid Hill Park provided the only outdoor swimming pool in the state of Maryland open to black athletes. The "Number Two Pool" served as a training ground for some of the finest competitive swimmers of the era. The lifeguards and young athletes who trained there during summer mornings, both men and women, were role models for boys and girls who played under their watch when the pool opened to the public at midday. Cornelius "Nick" Johnson recalls, "In the early '40s I saw Gilbert Brown as a lifeguard at the pool. I wanted to be like him and few grew up to become a lifeguard."

Most of the other parks in the city had developed something of a hostile and racist patronage. Druid Hill had relatively decent facilities available to African Americans. Even with this haven, there were still areas within the park that were problematic. The black patrons tried to stay clear of the eastern section of the park, which established itself as a white section and was thus dangerous to blacks. In 1909, a playground for black children was built and the CPA organized a separate training for black leaders. By 1914, there were ten white playgrounds and only one black playground established in city parks. There were sixteen white and six black playgrounds established in city schools.

The whites-only pool was built in 1924. The pool was irregular in shape (280 feet by 180 feet) with depth progressing from 1 to 10 feet. It was very big, although not as big as the Clifton pool, which was considered to be one of the largest public pools in the country. The old pumping station served as the newly renovated bathhouse. There were problems with the building process, including bureaucratic and constructional difficulties as well as forces of nature, all of which caused extended delays. But the real trouble came when it was decided to fill the pool with water from the Jones Falls. Plans were made for opening day to be Sunday, August 17, 1924. There was something of an uproar, as only men and boys would be allowed to bathe. Women would be allowed the following Thursday, it was decided, and have their own day as well. As preparations were being made, V. Bernard Seims, water engineer, seemed to have made the decision to use the Jones Falls water. How this was allowed seems confusing, since as early as 1913 the water from the Falls was known to be a health hazard. Dr. C. Hampson Jones, commissioner of health, raised concern about the water supply, noting, "Jones' Falls was our greatest source of pollution in our water system and that is why we stopped its use for drinking purposes." After spending eight to twelve hours filling the pool with five million gallons of water from Jones Falls, the pool had to be drained because the water was deemed unhealthy. It was then refilled with filtered water, like the water used in the other Druid Hill Park pool. The refilling occurred on August 17.

The renovated pumping station that became the Field and Bath House was considered to be one of the most elaborate and "well-equipped structures of this kind in any municipal park in the country," according to the *Baltimore Municipal Journal* of April 10, 1924. But from the mid-1920s to the mid-1950s, the white marble bathhouse was off-limits to black people. Only whites were allowed to use it and the pool until 1956, when the pools were legally integrated. The building is now the headquarters for the Department of Recreation and Parks and was named the Ralph Waldo Emerson Jones Building, after the first African

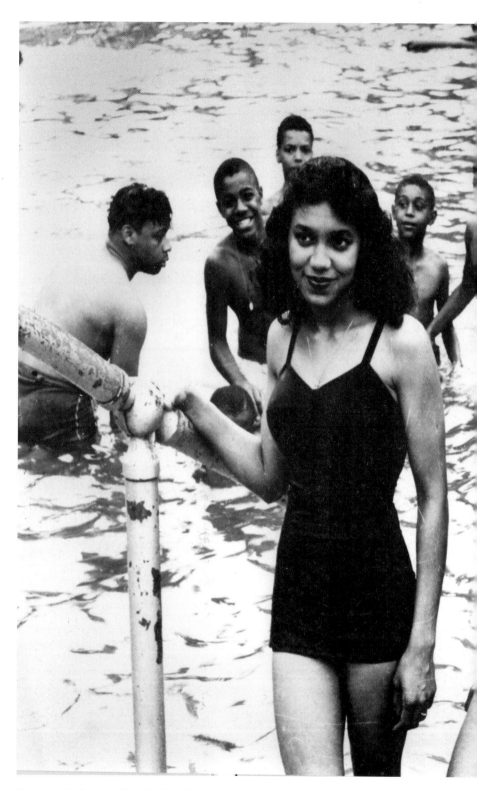

Bathers enjoying the #2 or "colored" pool.

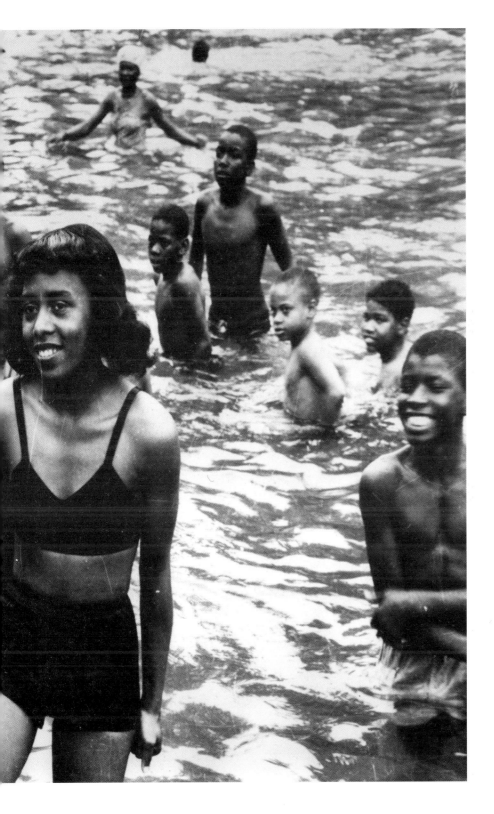

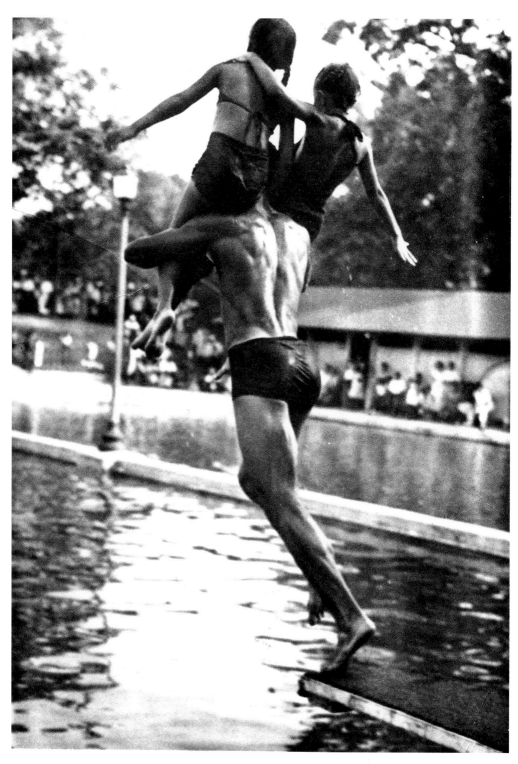

William Hall, lifeguard and swim instructor, jumping off the board with a child on each shoulder. Dr. Hall worked at the pool in the summer while in college.

American director of the Department of Recreation and Parks. The building won a 1994 Preservation Award sponsored by Baltimore Heritage, Inc.

Following the 1995 Master Plan of Druid Hill, the "Negro" area became the first to be renovated as a result of the overwhelming sentiment of neighbors, park users and persons who had fond memories of using the park during segregation. The area is now designed as a memorial landscape to honor the memory of segregation and the struggle to overcome it. Working with landscape designers and architects, African American artist Joyce J. Scott designed the paving pattern of the walkways through the grove and around the pool. The pattern of meandering coil and woven rope is based upon traditional African motifs symbolizing tranquility, safety and connections to community. The wave pattern of the roof of the men's changing building symbolizes water. The columns at the entry plaza mark the corners of the field house. The pool scupper, ladders and chair framework remaining are elements of pool use.

The Bernard Harris/Garrett Dichotomy

During much of this time, Dr. Bernard Harris was the lone member of the Parks Board who urged the administration to do away with the unfair, systematically oppressive policies. Dr. Harris served on the school board from 1952 until 1960. He was a member of the Maryland Athletic Commission, on the board of the National Conference of Christians and Jews and was involved with the Boy Scouts of America, serving on the executive board. In addition, he was a Mason, a Shriner and was deeply involved in his church. He was a surgeon for more than fifty years, practicing in the same office that he opened in 1924 right out of medical school. In fact, in 1969, Dr. Harris died in that office at the age of seventy-two. Always the champion of civic causes, Dr. Harris, as a member of the school board in 1952, voted successfully to allow thirteen black students to attend the then all-male, all-white Polytechnic High School's "A" course for Baltimore's top students. Dr. Harris became active in the parks during a critical time, as racial tensions were becoming more vocal.

Robert Garrett was one of the founders and board members of the Baltimore Museum of Art, chairman of the board of the Walters Art Gallery, and was on the board of trustees of the Peabody Institute. For many young men and boys of Baltimore, he was a hero. He served as president of the Young Men's Christian Association (YMCA) local branch in 1932 and, like Dr. Harris, was involved in the Boy Scouts of America. He served as chairman of the Public Improvement Commission and also was president of the Board of Recreation and Parks. However, for all the good he did, Robert Garrett was a fierce and lifelong segregationist. He was vocally and actively against desegregation. Robert Garrett shared the Progressive Party's failing theory that integration came at too high a cost and would be too problematic, opting instead for what they must have considered to be low-impact segregation.

Similar and passionate as both men were in their views of social action and helping Baltimore's youth, they could not have been farther apart when it came to matters of race

and integration. In 1947, Robert Garrett and Dr. Bernard Harris both sat on the Parks Board. Harris was the first black member of the Parks Board. He stood up for the rights of African Americans and demanded to know the reason behind the mistreatment of blacks. It was often Dr. Harris's voice alone that stood up in dissent against racist rulings. The intense and often bitter struggle between Harris and Garrett was representative of the city as a whole. Harris was fighting to eliminate racist action condoned by the city's policies. Garrett apparently stormed out of a March 1949 Parks Board meeting, after which Harris pressed for a vote on the improvement plans of the colored facilities. The remaining board members voted to speed up the process. In November of that year, an African American man was allowed to attend a class on gardening that was to be held in Druid Hill Park. Garrett fought against this and was outvoted.

Playing for Civil Rights

Druid Hill Park has played an interesting role in the history of race relations in Baltimore. It has been at the forefront of social action and has been the stage of protest that led to large-scale changes throughout the city. At once home to segregation and a leader in desegregation, Druid Hill Park reflected and shined the light of contemporary society.

By the late 1940s, the "colored" facilities were in deteriorated condition. There was not even pretense at "separate but equal." The tennis courts, in particular, were in a terrible state. In addition, there were only a few courts, totally inadequate for the number of tennis club players who were supposed to be using them exclusively. Finally, on July 11, 1948, the Young Progressives of Maryland, in conjunction with the Baltimore Tennis Club, staged a now-famous tennis match. It was one of the very first demonstrations against segregation in Baltimore. It represented a chink in what H.L. Mencken called the "Georgia Cracker" in Maryland. It took place six years before the *Brown v. Board of Education* decision and seven years before the Montgomery, Alabama bus boycott.

These members of the Young Progressives of Maryland were an interracial group of residents who lived in the neighborhood, ranging from eighteen-year-old students to men and women in their forties. There was political as well as social motivation, as it was an election year. The reasons for the match ranged from the demand for better courts to a demand for equality. The "Negro" courts were used by some of the greats in tennis, despite their dismal condition. Arthur Ashe and Althea Gibson are two who trained with Dr. Walter Johnson, a physician and talent scout from Virginia who brought both players to Druid Hill courts in the 1940s and 1950s.

There had been no intention of keeping the game quiet. The organizers (attorney Harold Buchman, director of the Maryland chapter of the Progressive Party, Stanley Askin and Maceo Howard of the Baltimore Tennis Club) contacted the press, the police and the Parks Board. They sent out pamphlets and used slogans such as "Jim Crow is Un-American" and "End Discrimination in Public Parks." They knew that there could be trouble and were prepared to face attempts at being thwarted, including confrontation or arrest. More than five hundred supporters gathered around the courts that day to watch

as the players began their match at 2:00 p.m. Almost immediately, police demanded they leave. The male players sat down on the courts and had to be taken bodily into paddy wagons to the hisses and jeers from the crowd. The police also arrested the female players, taking all down to the Northern District Police Headquarters.

Labor lawyer I. Duke Avnet took the case pro bono and was able to secure the release of twenty-four people who were arrested. The Supreme Court refused to hear the case. Columnist H.L. Mencken wrote a scathing article, likening the Parks Board to the Ku Klux Klan, demanding that "such relics of Ku Kluxry be wiped out in Maryland" and dismissing the erroneous charge by Mayor Thomas D'Alessandro Jr. of Communist-inspired politics on the part of the demonstrators. This would be Mencken's last column published. He was vocal and virulently opposed to segregation when he was hit with a stroke that left him unable to read or write until his death in 1951. Mitzi Swan, née Freishtat, was a young white player and an active member of the Young Progressives. She didn't think of herself as a radical or someone with outlandish demands. "The park wouldn't allow us to play," she explained in a *Baltimore Sun* article in 2003. "It wasn't a law. It was the policy." She went on to acknowledge the problems at the park with the facilities for the black players: "They were overgrown with weeds and ruts." It was Swan and black tennis player Mary Coffee who stepped onto the court to play the interracial

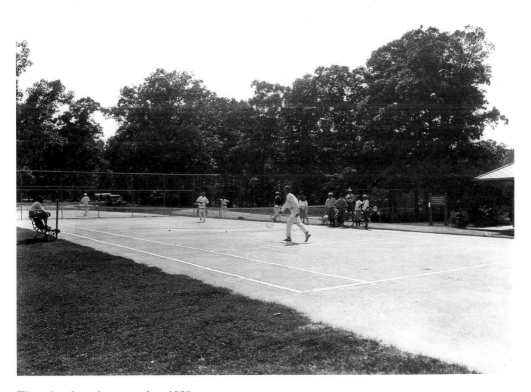

The colored tennis courts, circa 1930.

game. Within moments the police removed them. Swan met her future husband that day, as he too was arrested for protesting. She never felt that she was doing anything but standing up for what was right. "It was what I believed in."

Royal Weaver was also arrested that day. During a time when tennis was mostly for the affluent, the black tennis players were mostly teachers. Weaver was new to Baltimore and had grown up in a middle-class family in Philadelphia. He moved with his wife, Hermione, to her hometown of Baltimore. Although Weaver, a fair-skinned man easily passing for white, had never done anything like this, he stood up that day and made sure that the police knew he was not white when they arrested him.

The demonstrators did a great service by bringing the issue to the public attention. Their display showed how absurd it was that people couldn't play a game of tennis without fear of being arrested simply because of the color of their skin. However, for three more years the board's segregationist policies stayed in place, in large part due to Robert Garrett's loud segregationist voice.

In October 1949, a fight between black and white boys resulted in the stabbing death of a teenage African American. Bernard Harris openly blamed the terrible tragedy on the board's segregationist policy. Lynchings and calls for violence were still prevalent. Attempts at integration often led to violent protests by bigoted whites. While Garrett used this violence to prove his point that segregation was necessary, integrationists like Harris used this violent behavior to prove that separate only led to alienation and racism. Harris declared that had integration been the norm, there would not have been racist and territorial violence in Baltimore.

That same year, after bitter battles against the inevitable demise of the racist, unequal and terminally bigoted segregation policies, Garrett resigned from the Parks Board along with two other members. Unions and PTAs that were pro-integration had been calling for him to step down. His policies were offensive and he was unmoved by popular outcry. It was with the departure of Garrett that true integration in Druid Hill Park was allowed to move forward.

Part Two

THE PRESENT

Alive in the Park

There is a timelessness one feels in the splendor of Druid Hill Park's 746 acres. When visitors walk along the miles of old carriage roads through the forests or cycle along the back roads, the ancient land feels unchanged. This is due to planning and careful design that allowed this beautiful space to once again feel pristine and untouched. Great natural landscape designs should be invisible and only the beauty of nature should show through. With its rich history, its winding paths through fields, forests, streams and woodlands, Druid Hill Park is now one of the most beautiful parks in America. So much of the feel of the park has remained unchanged since the earliest days, although the flora has, in fact, been altered to a great degree.

The Sentinels

Beautiful forests and groves still grace the landscape and almost 135 acres of forest cover the northern end of the park. The Department of Natural Resources identified four groupings of trees. Stands of tulip poplar/beech are the most common, followed by white oak/beech, beech and mixed oaks/tulip poplars/beech/ash. A healthy understory can be found in some areas, while invasive species such as English ivy, ailanthus, porcelain berry and Norway maple are prevalent in others.

The shady rolling lawns of Druid Hill are one of its prominent features and define the park to many of its visitors. A 1993 tree inventory and management plan by the Forestry Division and the Yale Urban Resources Initiative found a preponderance of large old trees (over one hundred years) led by the ever-present sentinels, the oaks. Additional species include American beech, tulip poplar and white ash. Remnants of formal landscape designs from the nineteenth century can be seen in the horse chestnuts planted in the early 1900s along Swann Drive and those planted along the Mall. It is said that some of the trees in Druid Hill Park, along with Cylburn Arboretum, are the oldest

in the state. The Osage orange near the reptile house on Greenspring Avenue is close to four hundred years old. The park also contains large specimens of sassafras, black gum and red, white, English and overcup oak. One can also find native fruits and nuts such as persimmon, apricot, paw paw, walnut and hickory.

Huge trees still stand as living proof of the past glory of the forest. There are Victorian photographs taken near Prospect Hill of tiny beeches that stood where huge beeches now stand. Old pictures from the 1870s depict fragile cypress saplings held up with wooden braces, where there are now majestic cypress standing three stories high. In the 1940s, people flocked to the park to see the cherry blossoms from the trees that had been planted in the 1930s, and today, usually near the second week of April, the Kwanzan and Yoshino cherries bloom around the reservoir. There is no reason to flock to Washington, D.C., when Baltimoreans can come to Druid Hill. Part of the magic of the place seems to be in its mix of timelessness and growth.

In 1972, Druid Hill Park was listed on the National Register of Historic Places. A twenty-year master plan was also hatched, aimed at the reconstruction and renovation of the park and zoo. A new era had begun for Druid Hill Park.

Feathered Friends, Furry Friends and Other Residents

In addition to the trees and flora, many species of wildlife also make their homes in the park. Herds of white-tailed deer and families of red fox live here, along with cottontail

Maple. *Courtesy of Donna Stupski, 2007.*

Autumn color, as envisioned by Colonel Nicholas Rogers. *Courtesy of Donna Stupski, 2007.*

rabbits, raccoons, chipmunks and squirrels. There are many habitats: wetlands (from underground streams), meadows, forests and fields. The woodlands provide excellent nesting areas for a great many creatures. The zoo has guardianship of some native box turtles that have been released to live in the park. These friendly creatures trundle through the grasses and cool shade of the forest.

It has been calculated that over 175 species of birds can be found throughout the park, some common and some rare. Some are migratory, some come to breed and others live here year-round. Although in a breeding bird survey performed in 1993, the woodlands were not found to be quality interior breeding habitat for Forest Interior Dwelling Species (FIDS), they are a valuable breeding habitat for species sensitive to urban conditions. Of the twenty-nine species identified as possibly breeding in the park, eight are uncommon to Baltimore. Cardinals, blue jays, mockingbirds, orioles and many other colorful species fill the air with song. Small mammals and lizards provide prey for the hawks and owls, and much vegetation and soils (worms, insects, etc.) offer food for other species.

Courtesy of Donna Stupski, 2007.

According to Bryce Butler of the Baltimore Bird Club, a chapter of the Maryland Ornithological Society, fifty species of birds were sighted by a group of birders in Druid Hill Park during a four-hour period on the last Sunday of April 2007. The club's 2006 list of birds sighted in Druid Hill Park is as follows:

10 Canada geese
2 wood ducks
4 mallards
1 great blue heron
2 black vultures
2 turkey vultures
1 osprey
2 red-shouldered hawks
2 red-tailed hawks
48 ring-billed gulls
12 herring gulls
19 great black-backed gulls
7 rock pigeons
11 mourning doves
20 chimney swifts

3 red-bellied woodpeckers
2 downy woodpeckers
2 northern flickers
2 eastern phoebes
2 eastern kingbirds
1 white-eyed vireo
2 blue-headed vireos
2 warbling vireos
44 blue jays
7 American crows
3 fish crows
4 tree swallows
4 north rough-winged swallows
19 barn swallows
4 Carolina chickadees

3 tufted titmice
1 white-breasted nuthatch
2 Carolina wrens
2 blue-gray gnatcatchers
3 wood thrushes
66 American robins
5 gray catbirds
2 northern mockingbirds
57 European starlings
1 Nashville warbler
2 yellow warblers
4 yellow-rumped warblers
2 black-throated green warblers
2 black-and-white warblers
1 Louisiana waterthrush
1 common yellowthroat

1 scarlet tanager
1 eastern towhee
1 song sparrow
3 white-throated sparrows
6 northern cardinals
13 red-winged blackbirds
3 common grackles
5 brown-headed cowbirds
3 orchard orioles
3 Baltimore orioles
2 house finches
9 American goldfinches
13 house sparrows
461 birds total, 59 species (7 warbler, 3 vireo species)

The Baltimore Bird Club coordinates an annual spring and fall counting of chimney swifts at the chimney of the Rawlings Conservatory during their migration. The birds' ultimate destination is the Amazon Basin of Peru, where they spend the winter. The small, grayish birds eat, drink and bathe in flight. When they do land, they need to climb a vertical surface in order to fly again. They create basket-style nests on the inside of the chimney walls. In 2006, 4,680 chimney swifts were counted at the conservatory.

The New Zoo

With its bucolic and humble beginnings, the Maryland Zoo in Baltimore is now an award-winning zoo. In 1994, the Children's Zoo was voted the best in the United States. It is home to over 2,700 animals, including more than 285 mammal, bird and reptile species. Education and conservation are the real focuses of today's Maryland Zoo. The zoo participates and, in fact, has initiated some wonderful conservation programs. In addition to instituting breeding programs for many of the world's endangered animals, the zoo was also one of the initiators and founding members of Project Golden Frog. This joint project between institutions in Panama and the United States strives to save this tiny creature from extinction. In 2005, the Mountain Gorilla Veterinary Project found a new home at the Maryland Zoo in Baltimore. The zoo is an active participant in polar bear conservation and has been a sponsor for youth science camps and educational programs at the zoo and abroad.

Chapter 2.

The Hands of Humans

Throughout the park, there are recognizable monuments to different eras: the ancient undulating fields, eighteenth-century graveyards, the conservatory that shines in its Victorian splendor, the zoo that reflects its own historical origins and the disc golf course that hails a more modern distraction, to name just a few. The multidimensional nature of Druid Hill Park allows for the locals and the tourists to enjoy myriad pleasures. With its historic structures, pools, playing fields and woods, Druid Hill has more resources than most parks. As the Department of Recreation and Parks strives to rebuild, renew and renovate, hidden beauty is being uncovered and spaces long neglected are finding new life. Fifteen Druid Hill Park structures were designated Baltimore City Landmarks in 1975, some of which include the arched gateway, the Chinese Station designed by George A. Frederick and erected in 1864, the conservatory of 1888, the Octagonal Shelter for the Park Commissioner's horses and the early nineteenth-century Federal-style house built by Colonel Nicholas Rogers and later altered by John H.B. Latrobe.

Master Plan

In 1993, a new vision for managing the park was prompted by years of dwindling resources and a great love for the health and vitality of the park. The master plan incorporated the Department of Recreation and Parks' Strategic Plan for Action to "preserve, protect and enhance its parklands…to improve the physical and mental health of its people and the ecological health of the region and to invigorate the human spirit for generations to come." As part of the master planning process, consultants drafted plans and community members and users of the park framed a vision for the park that protects its history while providing a vision for its future. The result was a comprehensive look at the history and current conditions of Druid Hill and recommendations on how to move forward with the management of the park. The publication "Renewing Druid

Latrobe Pavilion. *Courtesy of Donna Stupski, 2007.*

Swimming pool. *Courtesy of Donna Stupski, 2007.*

Hill Park: A Vision for the Future of Baltimore's Great Park" was published in 1995 and is used as a basis for capital projects and planning.

The Howard Peter Rawlings Conservatory Today

After being closed for almost two years, the newly renovated Baltimore Conservatory and Botanical Gardens was opened to the public in September 2004. In June of 2005, the conservatory was officially renamed to honor the late Pete Rawlings. Pete Rawlings, a Maryland state delegate, worked tirelessly to secure funds for the conservatory renovation. He was an avid and tireless defender of Druid Hill Park and in 1986 was named "Friend of the Year," an award given by the Friends of Druid Hill Park. The renewal project won a Baltimore Heritage Preservation Award in 2005.

As part of the restoration, the Victorian-era building grew from its original 1888 Palm House to include four houses showcasing plants from around the world. One can visit the Mediterranean, Tropical or Desert Rooms, as well as the Orchid Room. A beautifully designed pair of structures was built on either side of the Palm House for weddings, parties and meetings, showing off a grand modern style. This addition brought the conservatory into the modern world without compromising the integrity of its history. The conservatory also offers special seasonal floral displays and provides a respite from busy city life.

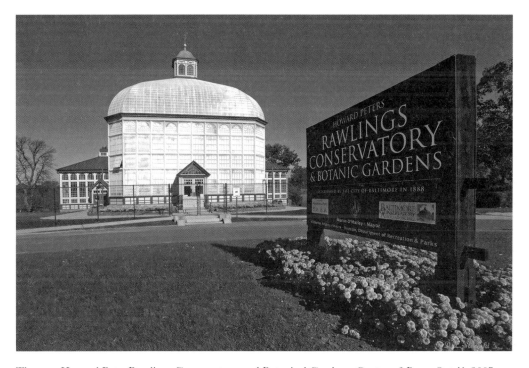

The new Howard Peter Rawlings Conservatory and Botanical Gardens. *Courtesy of Donna Stupski, 2007.*

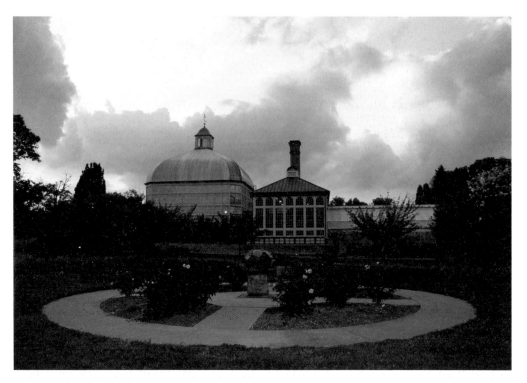

Conservatory from the gardens. *Courtesy of Donna Stupski, 2007.*

Conservatory orchid. *Courtesy of Donna Stupski, 2007.*

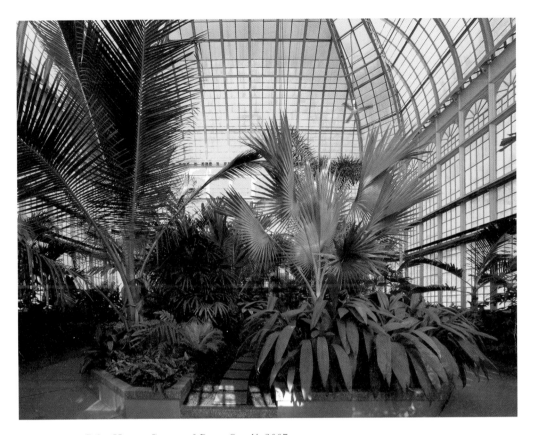

Conservatory Palm House. *Courtesy of Donna Stupski, 2007.*

The Jones Falls Trail

One of the great recent additions to Baltimore has been its trails. Actually, many trails in the area follow tribal paths of ancient dwellers. The Olmsteds had visions of linking trails back in 1904. The Gwynns Falls Trail and Jones Falls Trail link parks and streams along their watersheds and provide a splendid venue for cyclists, hikers and lovers of urban nature. Both trails are a part of the Chesapeake Bay Gateway Network (CBGN)—a nonprofit organization that promotes the connection of museums, parks, nature conservatories and other attractions that are part of the Chesapeake experience—and link together at the visitors' center at the Inner Harbor.

The Jones Falls Trail runs through the center of the city, following much of the Jones Falls. The design was such that the trail connects twenty neighborhoods and 1,500 acres of parkland, including Druid Hill Park, Cylburn Arboretum and the Inner Harbor. The first phase, completed in 2004, connects Penn Station to Druid Hill Park and the next phase, winding 2.75 miles through Druid Hill, passes the pool, the reservoir, the conservatory, the zoo and heads down the back wooded hills in the north end of the park. The Jones Falls Trail is Baltimore's link to the East Coast Greenway, a national trail system that runs along the coast from Maine down to Florida.

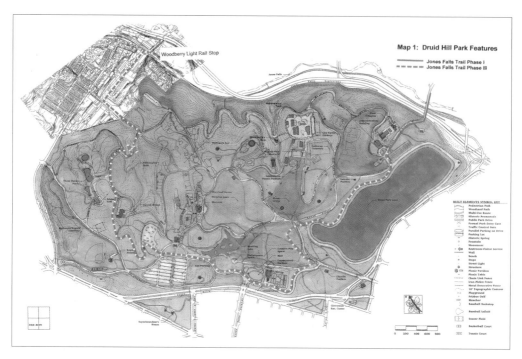

Map of park showing Jones Falls Trail.

People enjoying the Jones Falls Trail.

Reservoir. *Courtesy of Donna Stupski, 2007.*

Lost But Not Forgotten

When Druid Hill Park was purchased by Baltimore in 1860, there were several structures, some inhabited, which were standing on the estate. Many were in disrepair and the city took them down. Today, only the mansion house still remains. The casual archaeologist can investigate ruins like those of the blacksmith's shop, the superintendent's house and some of the historic springs, as well as statues and large historic trees.

In addition to buildings created for the land and artifacts from the area, an interesting twist of history landed in Druid Hill Park in the 1960s. A group of stones known as the Susquehanna River (Bald Friar) Petroglyphs (stones carved with ancient symbols) were quietly stored by the maintenance yard. The stones are so old that apparently even the local Indian population did not know who had carved them when asked by William Penn in the 1680s. It is possible that the stones are prehistoric, although some suggest the carvings were made approximately 1000–2000 BC. In the 1920s, plans were made for the construction of the Conowingo

Blacksmith's repair shop, circa 1880.

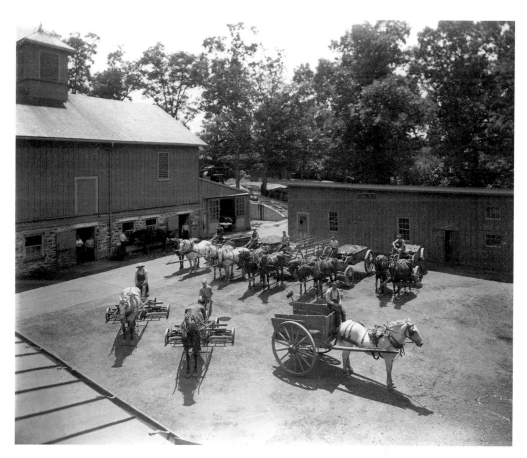

Stable yard, circa 1900.

Dam and the American Academy of Science blew up the stones with dynamite in order to protect them. Some big chunks were glued (cemented) together, and in the 1960s several were brought to Druid Hill Park. In 2006, the Maryland Historical Trust moved the stones to the Maryland Archaeological Conservation (MAC) Lab at Jefferson Patterson Park and Museum in Calvert County. There the stones are being studied and a conservation effort set in place.

Part Three

THE FUTURE

Commitment to Green

In her 1982 thesis, "The Architecture and Landscape of Druid Hill Park, Baltimore," Peggy Bruns Weissman notes, "In a large urban park like Druid Hill can be seen the balance and integration of three often opposing forces in America: art, nature, and technology." This has always been true of Druid Hill, as landscape designers' visions become lost beneath the waves of green and trees struggle to survive against the incoming traffic. Still, today and tomorrow, as much as yesterday, the artists, naturalists and lovers of Druid Hill continue to adore the magic offered on this land. Designers and visionaries with their hands on the pulse of the park will look into the future with a clear sight of the past to guide them.

Friends of Druid Hill Park

Everyone needs a champion, and Druid Hill has the Friends of Druid Hill Park. In the 1980s, this advocacy group published an excellent book on the history of the structures and statues in the park. Continuing through the mid-1990s, the Friends of Druid Hill Park published newsletters and vocalized support for the park. The group rallied to prevent the Columbus statue from leaving the park, raised money to restore the World War I memorial grove and assisted in preventing a private parking lot from being constructed in the park. After being dormant for a number of years, the group has been resurrected anew. There is an active board and subcommittees on topics ranging from marketing to historic preservation. The Friends have been instrumental in the promotion of the park and the protection of its many treasures.

Moorish Tower. *Courtesy of Donna Stupski, 2007.*

Promise for the Future

Druid Hill Park began with a vision by the newly formed Park Commission and the commitment of talented and committed citizens. A large, bucolic park filled with historic features, recreation amenities, forests and open treed lawns was created and, despite periods of strife and struggle, was open to all citizens of Baltimore.

When the park was first purchased, revenues from the passenger railway were used to dramatically upgrade and enhance its features. But with that revenue long gone, the park has faced dwindling resources over the years. Heavy use of recreation facilities and natural areas compounded by insufficient funds left the park a "tarnished jewel." In the upcoming years, the Department of Recreation and Parks has committed to putting millions of dollars worth of projects into the park as usage and interest in Druid Hill climbs.

In order for Druid Hill to live up to its potential as a truly great urban park, as it was imagined by its early proponents, there must be strong public and private willingness to recognize the inimitable value it offers to Baltimore. Luckily, Baltimore is a city that is ready to embrace the rich and wonderful history of Druid Hill Park, with its woven stories, lives and families. The park is full of dichotomies, transitions and acres of beauty. But Druid Hill Park is only a part of the whole story. Baltimore is one of the luckiest cities in the world. It has oases of green that people in most cities can only find in their dreams. With incredible foresight or sheer serendipitous luck, Druid Hill Park's founding fathers gave something sacred to Baltimore's citizens. It is up to us all to carry the torch, to protect and love all of our parks so that Druid Hill and her sisters will be there for our children, and theirs.

Bibliography

Books

Birnbaum, Charles A., ed. *Pioneers of American Landscape Design*. Washington, D.C.: U.S. Department of the Interior, 1993.

Bowditch, Eden Unger. *Baltimore's Historic Parks and Gardens*. Charleston, SC: Arcadia, 2004.

Brosius, Myra, Gennady Schwartz, Marlyn Perrit and Baltimore City Department of Recreation and Parks. *Renewing Druid Hill Park*. Baltimore: Baltimore City Department of Recreation and Parks, 1994–95.

Friends of Druid Hill Park. *Druid Hill Park Revisited: A Pictorial Essay*. Baltimore, 1985.

Holcomb, Eric. *The City as Suburb: A History of Northeast Baltimore since 1660*. Center for American Places, Inc., 2005.

Howard Peter Rawlings Conservatory and Botanical Gardens. *Volunteer Handbook*. Baltimore, 2006.

Kelly, J.V. Public Parks of Baltimore No. 3. Compiled for Board of Park Commissioners, 1928.

———. Public Parks of Baltimore No. 4. Compiled for Board of Park Commissioners, 1929.

Kessler, Barry. *The Play Life of a City—Baltimore's Recreation and Parks 1900–1955*. Baltimore, 1988.

McGerr, Michael. *A Fierce Discontent; The Rise and Fall of the Progressive Movement in America, 1870–1920*. New York: Free Press, 2003.

Sandler, Gilbert. *Jewish Baltimore*. Baltimore: Johns Hopkins University Press, 2000.

Schlesinger, Arthur M., Jr. *The American History Almanac*. New York: Perigree Books, 1983.

Sharf, John Thomas. *History of Baltimore City and County, from the Earliest Period to the Present Day: Including Biographical Sketches of their Representative Men*. Everts, 1881.

Various Contributors. *Baltimore: Its History and Its People*. New York, Chicago: Lewis Historical Publishing Company, 1912.

Weissman, Peggy Bruns. "The Architecture and Landscape of Druid Hill Park, Baltimore." Master's thesis, University of Virginia, May 1982.

Articles

Akerson, Louise E. "Preserving Green Space Druid Hill Park in Baltimore, Maryland." Baltimore Center for Urban Archaeology, Baltimore City Life Museum. 1992.

Baltimore Sun, 1860, 1961.

Bevan, Edith. "Druid Hill, County Seat of Rogers and Buchanan Families." *Maryland Historical Magazine* 44, no. 3 (September 1949).

Brosius, Myra, and Mark Cameron. *Discovering Baltimore's Parks: The Legacy and an Overview*. Second ed. Baltimore City Department of Recreation and Parks.

Daniels, Howard. "A Public Park for Baltimore." *The Horticulturist*, circa 1860.

Durett, Dan, Associates. "The Druid Hill Park Impact Study." Draft prepared for Sugarloaf Regional Trails, Inc. June 1985.

Frost, Joe L. "The Dissolution of Children's Outdoor Play: Causes and Consequences." Paper, 2006.

Jordan, Cheryl Lynn. "The Evolution of Baltimore City Bureau of Recreation, 1940–1988." 1993.

Kowsky, Francis. "Review of *Pioneers of American Landscape*." *The Journal of the Society of Architectural Historians* (September 2001).

Maryland Historical Magazine (Fall 1979): 219.

Orser, W. Edward. "The Contested Terrain of Nineteenth-Century Urban Landscape Design." *American Quarterly* (December 1988).

"Thunderstorm at Dr. Buchanan's Home." *Maryland Gazette*, 1752. Reprinted in the *Maryland Historical Magazine* (Fall 1979): 225.

Udziela, Matthew. "An Assessment, Characterization and Analysis of the Hydrology and Drainage of the Sub-Watersheds of Druid Hill Park, Baltimore, Maryland." Yale/URI Working Paper #28, October 1995.

Websites

For various Enoch Pratt Library Biographical Sketches by Ella Lonn, undated, www.prattlibrary.org.

For various genealogies and family tree websites, www.rootsweb.org.

For academic articles on historic architecture, www.jstor.org.

Index